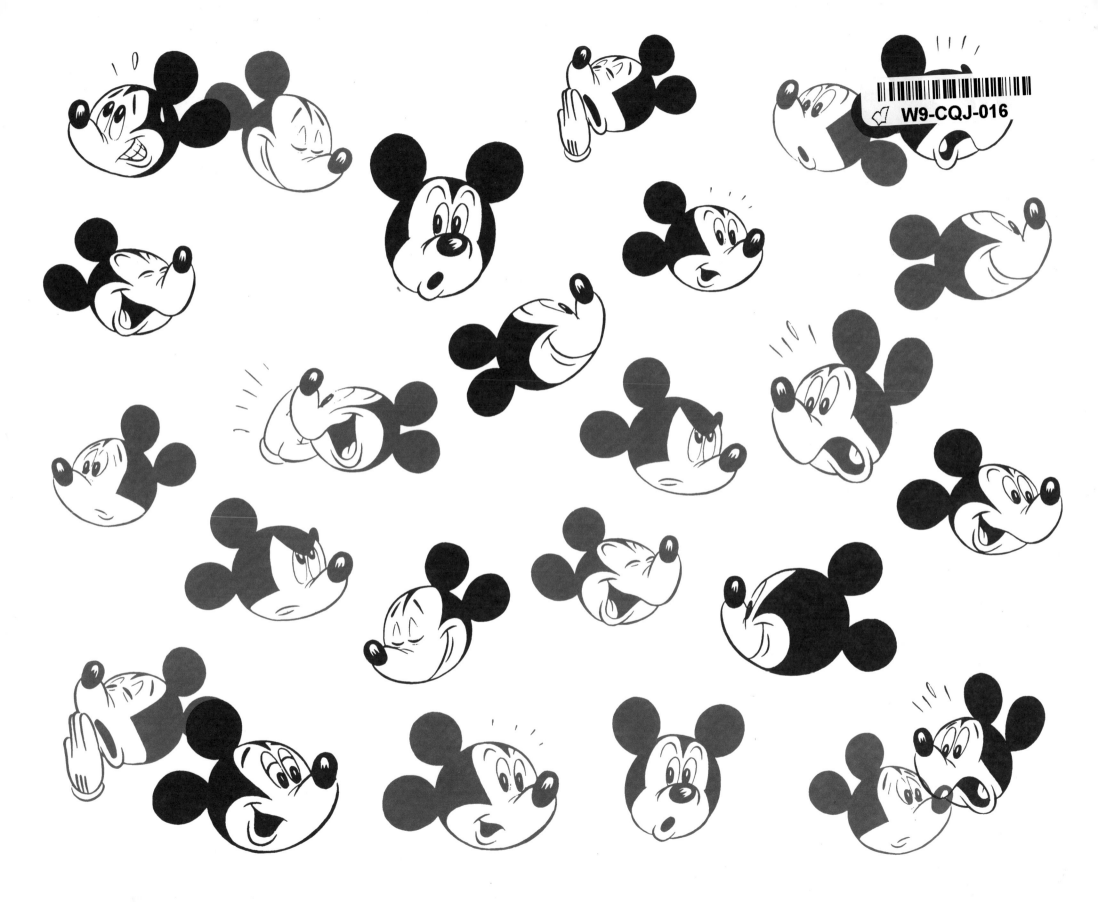

In memory of Ron Miller

MICKEY MOUSE

FROM WALT TO THE WORLD

ANDREAS DEJA

MICHAEL LABRIE

The Walt Disney Family Museum | San Francisco, California
May 16, 2019–January 6, 2020

THE WALT DISNEY FAMILY FOUNDATION PRESS

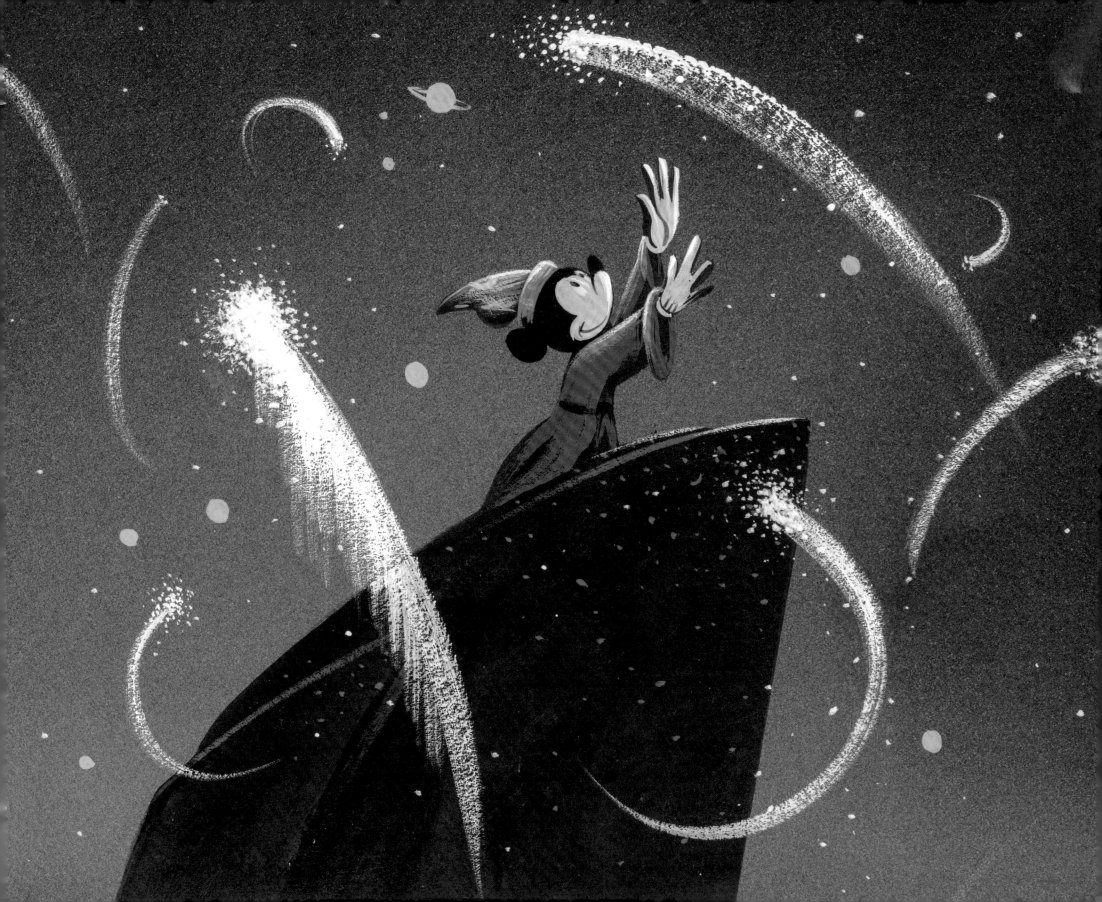

CONTENTS

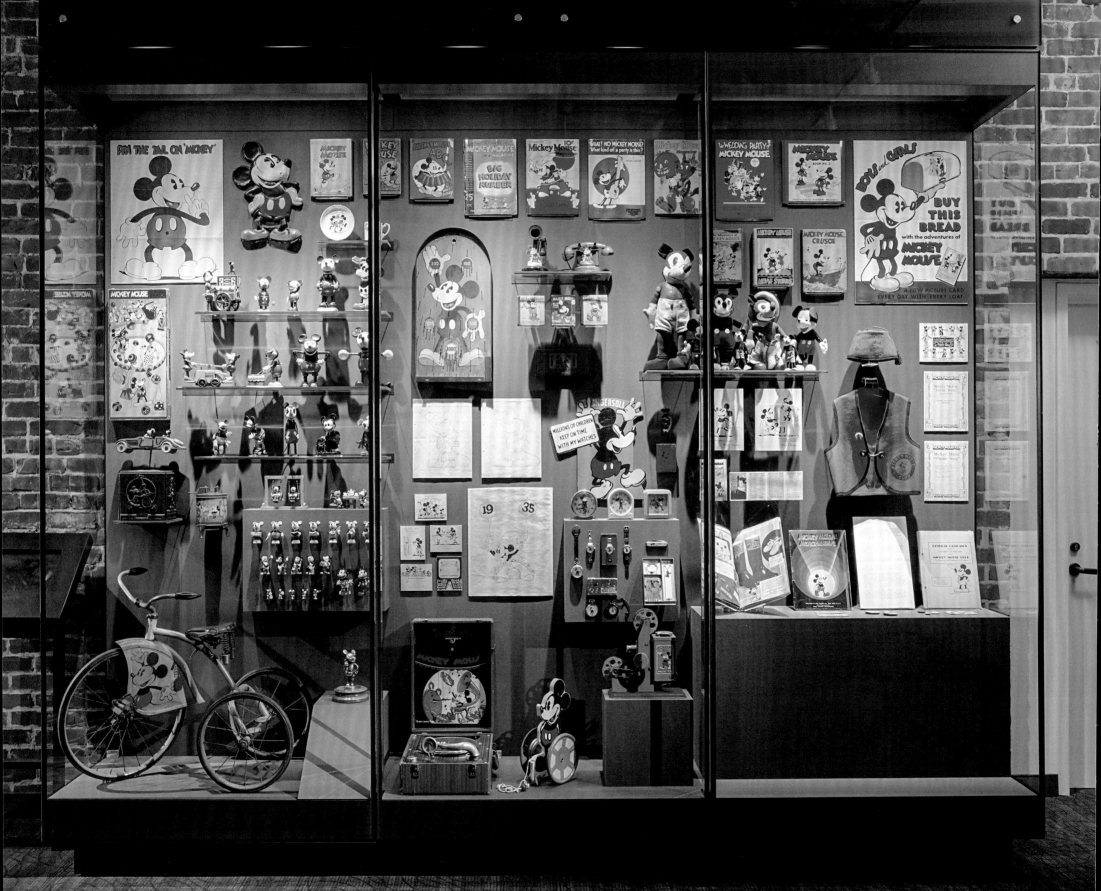

FOREWORD

In celebration of one of animation's most beloved and recognizable characters, I am pleased to share with you The Walt Disney Family Museum's *Mickey Mouse: From Walt to the World* catalog. The exhibition, which is the fundament of this catalog, chronicles Mickey's impact on art and entertainment over the past nine decades, telling the story of his origin, rise to fame, and enduring worldwide appeal.

Walt's story ultimately became one of overwhelming achievement. But his path to success was punctuated by challenges. When Walt lost creative control over his first cartoon star, Oswald the Lucky Rabbit, he quickly and resourcefully created a cartoon mouse. With input from his wife, Lillian, he named the new character Mickey Mouse. Mickey not only signified a fresh start for Walt, but the explosively popular character also afforded Walt significant new opportunities.

Mickey's impact resonates across the world, across generations, and across all walks of life. In recognition of this, the exhibition features artwork from the original Disney artists, modern artists, contemporary artists, and artists with disabilities. These works, displayed alongside each other, show Mickey's lasting influence, and also represent the museum's commitment to honoring the communities that have embraced and celebrated Walt's iconic character.

In the summer of 2013, I had the honor to accompany Andreas Deja to Napa for a meeting with Diane Disney Miller, the museum's co-founder, and her husband, Ron Miller. We had a lively and productive discussion, and it was in that meeting that Diane came up with the name for this exhibition. Although that was the first time I had the pleasure to spend time with Andreas, since then, I have been lucky enough to get to know him and count him as a dear friend. It has been the museum's honor to collaborate with Andreas—a leading authority on the history and animation of Mickey—in creating this compelling exhibition. Depicting 90 years' worth of material about this iconic character was an extraordinary challenge, but one that Andreas both embraced and delivered on in an extraordinary way.

I want to extend my deep gratitude to key lenders of this exhibition, including Bob Iger and Willow Bay, Damien Hirst, Ron Miller, and Andreas Deja. Our generous lenders and donors have allowed us the opportunity to showcase important and iconic works that tell the full story of Mickey Mouse.

Our goal in mounting *From Walt to the World*, and in publishing this catalog, is to share Walt's important and enduring legacy, embodied in his timeless character, Mickey Mouse. I hope that you enjoy this catalog as much as we have enjoyed creating it.

Kirsten Komoroske
Executive Director
The Walt Disney Family Museum

CURATOR'S NOTE

Fred Moore. Mickey Mouse drawing , c. 1940
Colored pencil and watercolor on paper | 10 x 10½ inches

I still remember when I first saw Mickey Mouse in one of his animated short films on my family's small television set. At the time, I was about seven years old and living in Germany. On the screen, Walt Disney introduced several animated highlights from Mickey's film career, all in black and white and dubbed in German. I found myself completely transfixed, staring at the television.

Here was this famous cartoon character I had seen in comic strips—but, up until then, I'd never seen him *in motion*. It was the most fascinating and appealing thing I'd ever seen. I started to wonder, *How do they do that?* Mickey wasn't just moving around on the screen—he was thinking and figuring things out and reacting. He was alive.

These early encounters with an animated version of Mickey left a deep impression on me. I wanted to be part of his world, part of the world of animation. Decades later, I applied to and was accepted by the Animation Department of Walt Disney Productions. A career spanning 30 years as an animator followed, during which I had the chance to animate Mickey Mouse on several occasions. The feature film *Who Framed Roger Rabbit* (1988) first gave me the opportunity to draw a few scenes involving Walt's iconic character, and, later on, I animated Mickey in a few short films, including *The Prince and the Pauper* (1990) and *Runaway Brain* (1995).

It was not easy to animate this superstar of a mouse. I found myself intimidated—not only by Mickey's fame but by the quality of the animation demonstrated in his films. Luckily, the Walt Disney Animation Research Library preserves all of Mickey's animated scenes in their original paper form. I studied some of these scenes, thumbing through the sheets like a flipbook, and several revelations came to pass.

One of those revelations was that several of Mickey's original animators—Ub Iwerks, Les Clark, and Fred Moore among them—applied little drawing "cheats" in order to maintain Mickey's appeal while he moved. For example, his ears never change in perspective but instead maintain the same round shape, no matter which way his head might turn. Another discovery I had was that Mickey's muzzle has a flat appearance when he looks into camera, but his nose moves upward when in profile. Perhaps none of this makes any sense, but, after breaking it down, it became clear that these small elements helped Mickey's face always come across as appealing and engaging while he was in motion.

Many animators, past and present, much prefer working on characters like Goofy or Donald Duck, because of their eccentricities. But I have always loved Mickey's smart and good-natured personality.

After years of working closely on the famed mouse, it has been a great honor to guest curate this beautiful exhibition for The Walt Disney Family Museum. A few years ago, the late Diane Disney Miller asked me to help plan an exhibition that would celebrate her father's most beloved character. I was flattered beyond words and accepted enthusiastically. I wish to thank President of the Board Ron Miller and Executive Director Kirsten Komoroske for their kind support during the planning stages of this exhibition. A special thank-you also goes out to the wonderful staff of The Walt Disney Family Museum; I loved working with all of you on *Mickey Mouse: From Walt to the World*.

Today, visitors to the museum can experience all facets of Mickey's astonishing career. Highlights include never-before-seen original animation drawings, rare vintage merchandise and products including, "How to Draw Mickey" instructions, as well as several fine art interpretations of the character. Everyone can rediscover why Walt Disney's Mickey Mouse has endured for so many years and continues to charm the world. Animator Ollie Johnston once said, "Walt was a force of nature!" and I believe this is evident even when looking at the very start of his career, thanks in part to the remarkable creation of Mickey Mouse.

Andreas Deja
Guest Curator

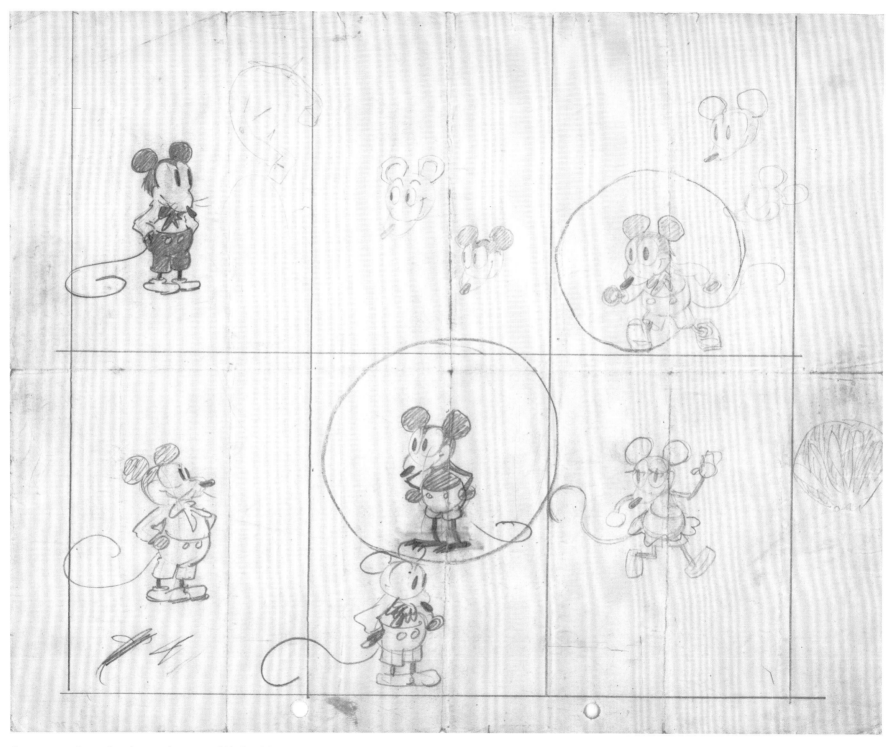

Concept art, the earliest known drawings of Mickey Mouse
Walt Disney, c. 1928
Graphite and colored pencil on paper | 9½ x 12 inches

INTRODUCTION

Walt Disney considered Mickey Mouse a symbol of his independence. But the impact of Walt's creation came to symbolize much more. Today, Mickey Mouse is viewed by many as an icon of American culture and entertainment, inspiring many generations, including mine.

Having worked with Walt over the years, including as executive producer of *Mickey Mouse Club*, the power of Mickey to both Walt and the world became increasingly evident to me over time. I see a lot of Walt in Mickey. Walt famously was the voice of the original character, but, more profoundly, he infused his own spirit into Mickey. And much like Mickey, Walt had an optimism that was infectious.

Before Walt passed away, he established a family corporation, Retlaw, which housed his family collection. For many years, Walt's brother-in-law and Retlaw staff member, Bill Cottrell, told us that there was something very special in one of the Retlaw safes. When Diane and I finally opened the safe, we were taken aback to discover the earliest known drawing of Mickey Mouse and Minnie Mouse on animation paper, dating back to 1928.

The discovery of this historic drawing emboldened Diane's drive to create a museum to pay homage to her father. But in envisioning the museum, Diane was clear that she did not want the spotlight cast on her. Instead, she wanted to focus on her father's legacy, and inspire the public with his story.

Six years ago, Diane chose the name of this special exhibition, *From Walt to the World*. It is my hope that her vision for this exhibition—honoring the legacies of both Mickey Mouse and his creator, her father—will inspire people the world over.

Ron Miller
In memoriam (April 17, 1933–February 9, 2019)
President of the Board of Directors
The Walt Disney Family Museum

"I only hope that we never lose sight of one thing—
that it was all started by a mouse."
—Walt

EVEN AFTER DECADES OF SUCCESS, Walt Disney always wanted the world to remember that his entertainment empire was "all started by a mouse." In a 1948 broadcast on the radio program *University of the Air*, Walt called Mickey Mouse a symbol of his independence—both financially and creatively. Mickey was, in a sense, born out of necessity: in 1928, the year of Mickey's debut, Walt's finances and creative prospects were at a low point. The near-immediate success of this simple and unassuming character gave Walt and his brother Roy the means to expand their modest cartoon studio and led to a plethora of new opportunities in animation and beyond.

After the Disney brothers lost creative control over Oswald the Lucky Rabbit—Walt's first venture into fully animated cartoons—they needed a fresh and appealing new series to keep their business afloat. As Walt liked to recall, on a train ride from Manhattan to Hollywood, he brainstormed ideas for a new character. After arriving in Los Angeles, he discussed his ideas with animator Ub Iwerks, his longtime friend from Kansas City, and chose a mouse. Walt's wife, Lillian, steered him away from the initial idea of naming the mouse Mortimer, and he settled on the name Mickey. Because of his early childhood admiration for Charlie Chaplin and his wistful Little Tramp, Walt felt his new character should have a distinct personality: Mickey Mouse, with his strengths and weaknesses, represented the "little guy" trying his best against all odds—not unlike Walt himself.

In collaboration with Iwerks and apprentice animator Les Clark, Walt brought Mickey—and Minnie—to life on paper for the first time in 1928. Iwerks gave Mickey form and movement, while Walt supplied the jaunty personality and voice. Practically overnight, Mickey rocketed to stardom when his first short picture, *Steamboat Willie* (1928), opened at New York's Colony Theater on November 18, 1928. Throughout the decade that followed, Mickey became one of the world's most recognizable and beloved movie stars and popular culture icons. At the height of his popularity in the 1930s, Mickey starred in at least 14 short films per year. In 1948, Walt commented, "[Mickey] has appeared in more pictures than any flesh and blood star." In fact, not counting cameo appearances, Mickey starred in 118 films before taking a hiatus from movies in 1953.

In the beginning, Walt said, "Mickey was simply a little personality assigned to the purposes of laughter," but he would prove to be so much more. Mickey Mouse, like his creator, would elevate the medium of animation to new heights, becoming synonymous not only with entertainment, but with innovation as well.

BLACK-AND-WHITE FILMS

IT WOULD BE INACCURATE TO SAY that Walt simply created Mickey out of the blue. He and animator Ub Iwerks were inspired by animated characters from other films of the time, including Winsor McCay's *Gertie the Dinosaur* (1914); Otto Messmer and Pat Sullivan's Felix the Cat, who debuted in the short *Feline Follies* (1919); Max and Dave Fleischer's Koko the Clown, who starred in the series *Out of the Inkwell* (1918-1929); and even Walt's own Oswald the Lucky Rabbit, who first debuted in the short *Trolley Troubles* (1927). Although this popular cast of anthropomorphic cartoon animals, all with their own distinct mannerisms and styles, paved the way for Mickey Mouse's introduction, there is no doubt that Mickey took the animation medium to new heights.

Looking back, it is difficult to truly comprehend the impact Mickey Mouse had on the movie-going public in 1928. Today's audiences are accustomed to new animated films appearing in theaters every month, along with weekly releases of their favorite animated series on television networks dedicated to cartoons. While animated shorts had become a regular part of programming in movie theaters by the early 1920s, often playing before full-length feature films as an added bonus for audiences, many of them were not particularly

engaging. These early shorts were oftentimes comic strips from newspapers, enlarged and projected onto a screen with rudimentary musical accompaniment; only a handful of characters experienced even a modicum of fame. Mickey Mouse would permanently change this paradigm.

Before Mickey became a near-overnight sensation with the release of *Steamboat Willie* (1928), there were challenges to overcome. No one had ever heard of Mickey Mouse, and Walt no longer had a distributor backing him after the loss of Oswald. In fact, prior to *Steamboat Willie*, Walt made two Mickey short films, *Plane Crazy* (released later in 1929) and *The Gallopin' Gaucho* (released later in 1928), but decided not to offer them to theaters. Walt had to do something entirely innovative to gain the attention of distributors, theater owners, and audiences. With *Steamboat Willie*, Walt took that big risk by trying a new "sound on film" technique. Talking pictures were on the rise in Hollywood—*The Jazz Singer* (1927) had recently become a huge hit—so Walt felt the time was right.

Ultimately, this innovation changed animation irrevocably and established a pattern in Walt's films. With each production, he raised the bar for technical excellence and compelling storytelling. As their ideas became more elaborate, Walt and his team focused on creating work that was relevant to the culture of the day or paid homage to historical moments and classic, well-known tales. For example, *The Mad Doctor* (1933) spoofs the Hollywood horror movie genre, which was gaining popularity at the time; *Mickey's Gala Premiere* (1933) reflects the great commercial success Mickey Mouse was having, portraying him as a celebrity (alongside his one and only sweetheart, Minnie Mouse) and mingling with caricatures of famous actors; and *Gulliver Mickey* (1934) transports Mickey to a world originally imagined by Jonathan Swift in his 1726 satire *Gulliver's Travels*.

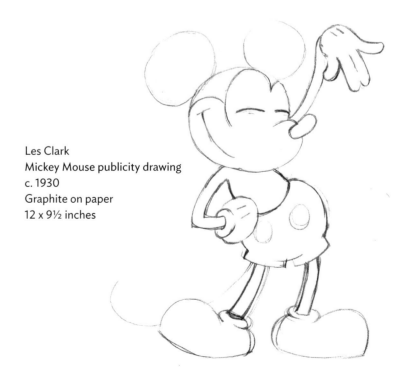

Les Clark
Mickey Mouse publicity drawing
c. 1930
Graphite on paper
12 x 9½ inches

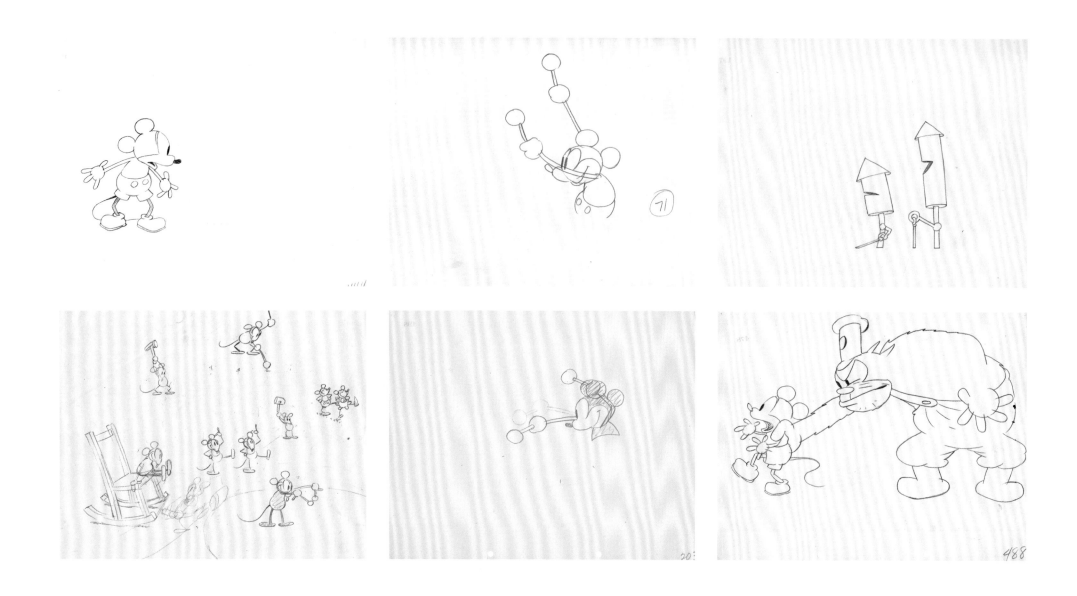

Ub Iwerks. Clean-up animation drawings. *Steamboat Willie* (1928)
Graphite on paper | 9½ x 12 inches each

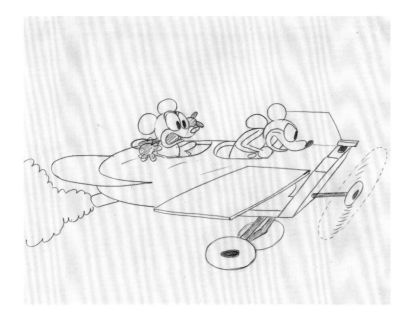

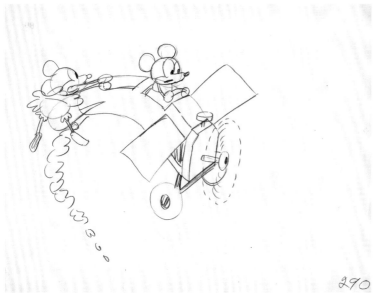

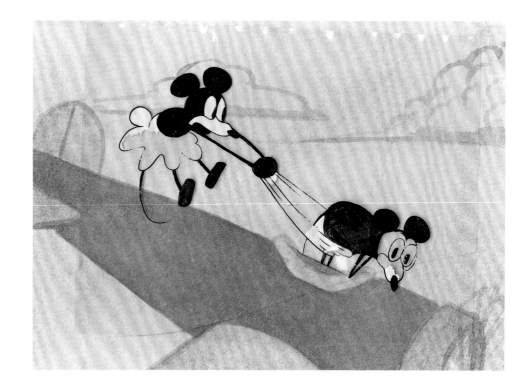

▲ Ub Iwerks. Clean-up animation drawing. *Plane Crazy* (1929)
Graphite on paper | 9½ x 12 inches

⬆ Disney Studio Artist. Clean-up animation drawing. *Plane Crazy* (1929)
Graphite on paper | 9½ x 12 inches

Disney Studio Artists. Original cel and reproduction background. *Plane Crazy* (1929)
Ink and paint on cel | 5¼ x 7¼ inches

Disney Studio Artist. Clean-up animation drawing. Thought to be from *The Jazz Fool* (1929)
Graphite and colored pencil on paper | 9½ x 12 inches

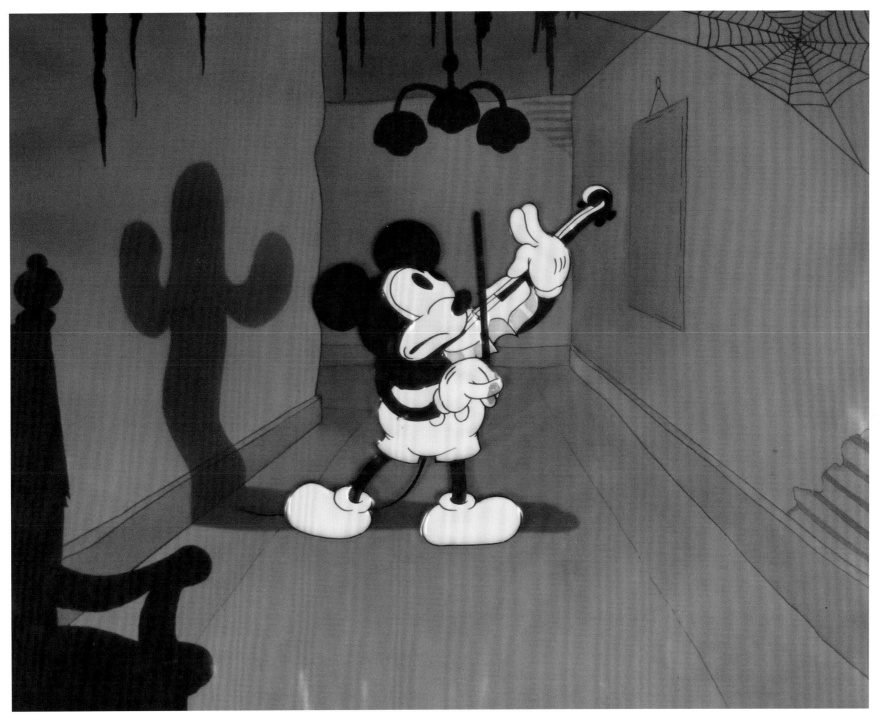

Disney Studio Artists. Cel from *Just Mickey* (1930), background from *The Haunted House* (1929)
Paint on cel and gouache on paper | 9½ x 12 inches

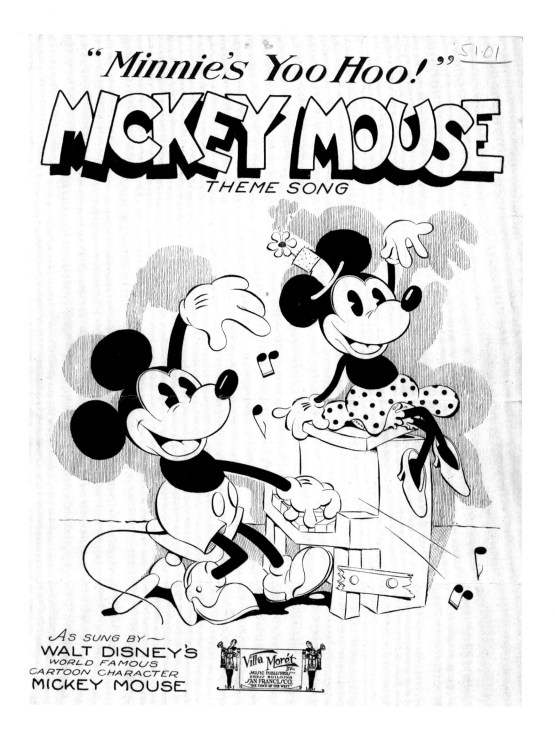

Disney Studio Artist. "Minnie's Yoo Hoo!" song sheet (1930), composed by Carl W. Stalling
Printed ink on paper | 12⅛ x 9⅛ inches
First performed by Mickey Mouse in *Mickey's Follies* (1929)

▲ Disney Studio Artist. Background painting. *The Karnival Kid* (1929)
Watercolor and ink on paper | 9¾ x 11⅜ inches

▲ Disney Studio Artist. Layout drawing. *The Karnival Kid* (1929)
Graphite on paper | 9½ x 12 inches

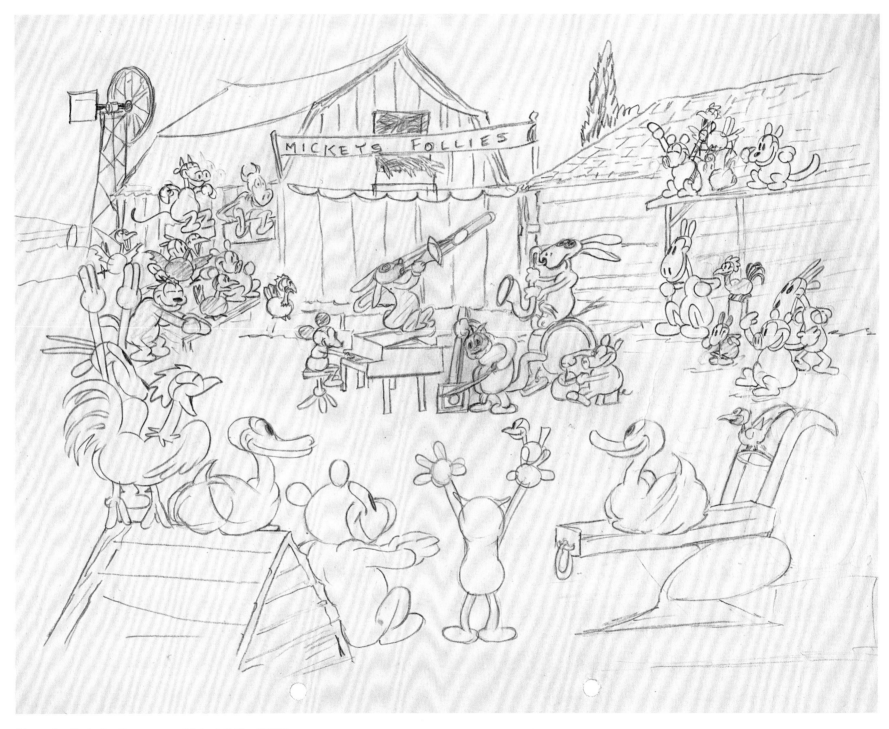

Disney Studio Artist. Concept art. *Mickey's Follies* (1929)
Graphite on paper | 9½ x 12 inches

12 x 5⁄8 inches 12 x 5⁄8 inches 11¼ x 9½ inches 11¼ x 9½ inches

Disney Studio Artists. Story sketches. *Jungle Rhythm* (1929)
Graphite and colored pencil on paper

12 x 8¾ inches

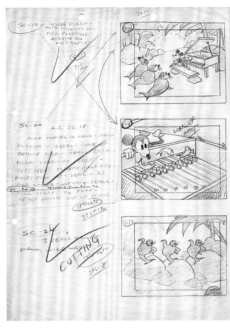

12 x 8¾ inches

12 x 8¾ inches

12 x 8⅝ inches

Disney Studio Artists. Story sketches. *The Castaway* (1931)
Graphite and colored pencil on paper

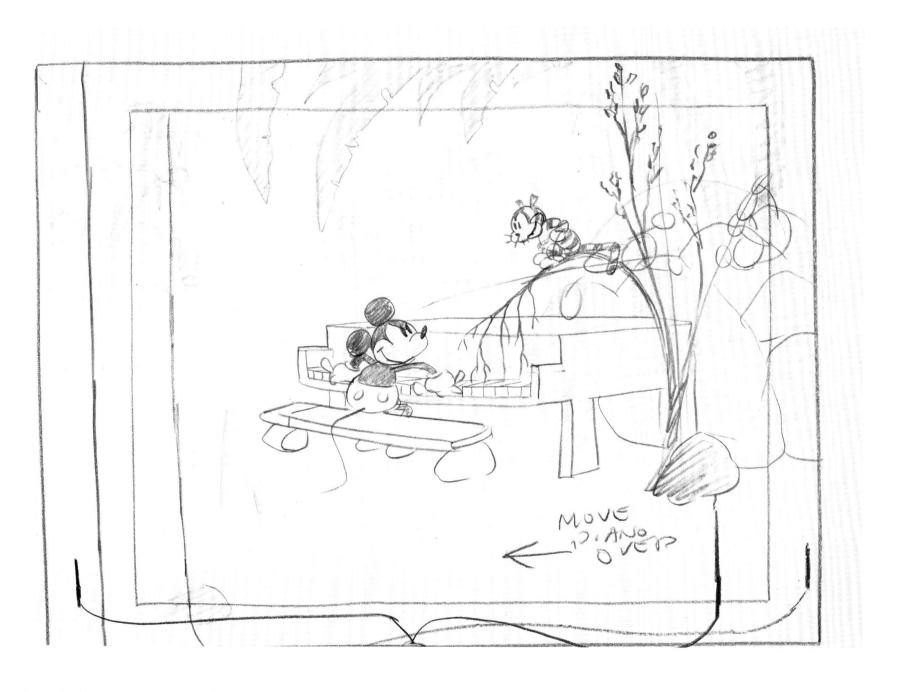

Disney Studio Artist. Layout drawing. *The Castaway* (1931)
Graphite and colored pencil on paper | 8 x 12 inches

opposite ▸ Disney Studio Artist. Layout drawing. *The Castaway* (1931)
Graphite and colored pencil on paper | 8⅝ x 12 inches

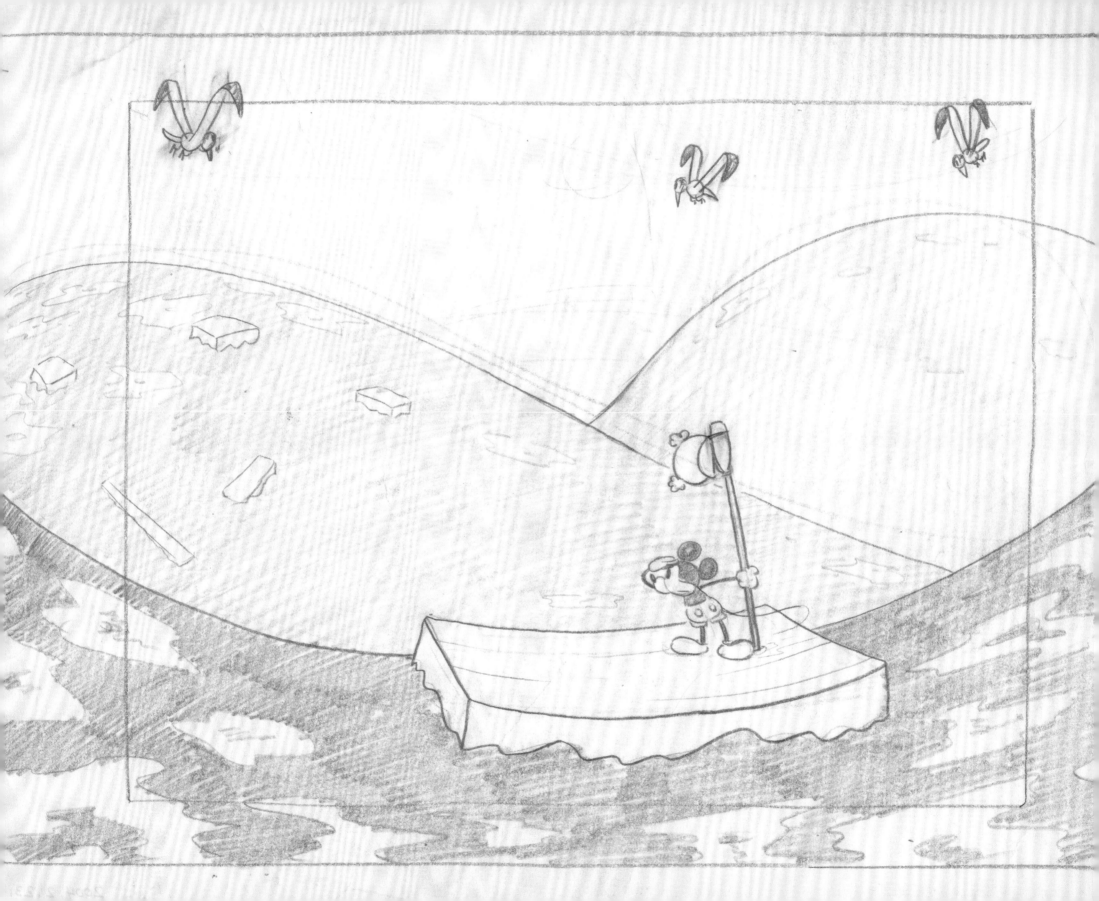

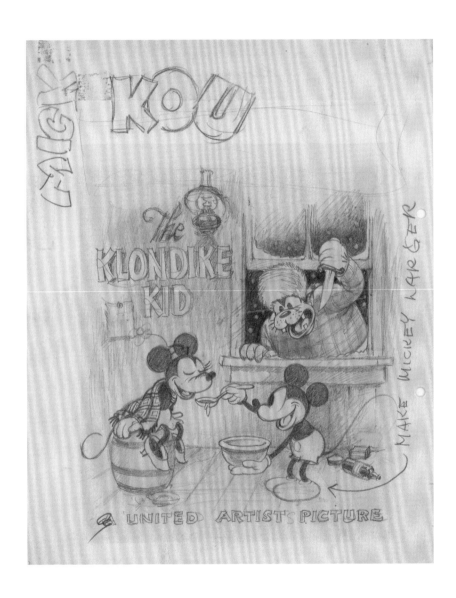

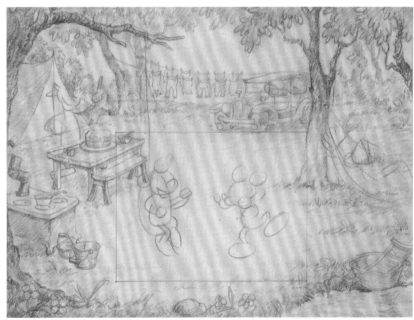

▲ Disney Studio Artist. Publicity art. *The Klondike Kid* (1932)
Graphite on paper | 9½ x 12 inches

◄ Les Clark. Concept art. *The Picnic* (1930)
Graphite on paper | 9½ x 12 inches

▲ Disney Studio Artist. Layout drawing. *Camping Out* (1934)
Graphite and colored pencil on paper | 9½ x 12 inches

↥ Johnny Cannon. Clean-up animation drawing. *Mickey's Good Deed* (1932)
Graphite and colored pencil on paper | 9½ x 11¾ inches

Disney Studio Artists. Layout drawings. *The Mail Pilot* (1933)
Graphite and colored pencil on paper | 9½ x 12 inches each

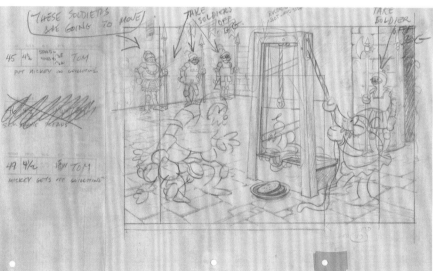

▲ Disney Studio Artist. Layout drawing. *Ye Olden Days* (1933)
Graphite on paper | 9½ x 12 inches

⬍ Disney Studio Artist. Layout drawing. *Ye Olden Days* (1933)
Graphite and colored pencil on paper | 18⅛ x 12 inches

▲ Disney Studio Artist. Layout drawing. *Ye Olden Days* (1933)
Graphite and colored pencil on paper | 9½ x 16 inches

⬍ Disney Studio Artist. Layout drawing. *Ye Olden Days* (1933)
Graphite and colored pencil on paper | 9½ x 12 inches

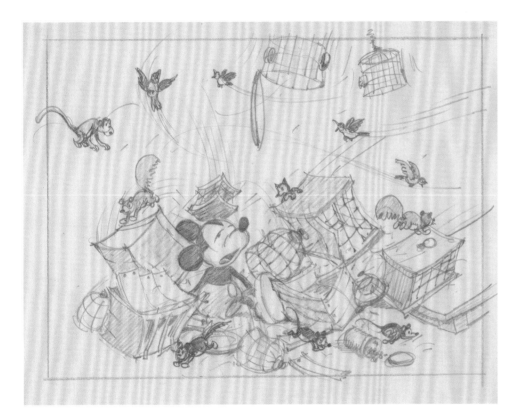

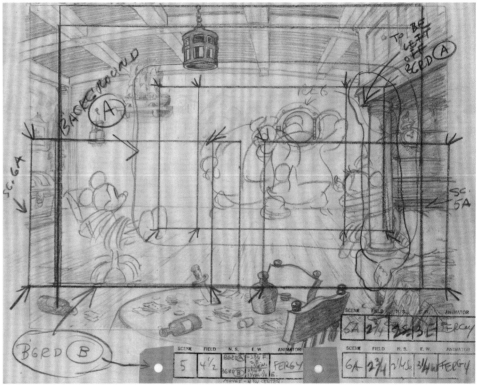

Disney Studio Artist. Layout drawing. *The Pet Store* (1933)
Graphite and colored pencil on paper | 9½ x 12 inches

Disney Studio Artist. Layout drawing. *Shanghaied* (1934)
Graphite and colored pencil on paper | 9½ x 12 inches

SCENE	FIELD	N.S.	E.W.	ANIMATOR
35	START 4½ - 1½ S&E MOVE TO 1½ S&W			ROBERTS

SCENE	FIELD	N.S.	E.W.	ANIMATOR
37	3½ F	1&S	1½ W	ROBERTS

SCENE	FIELD	N.S.	E.W.	ANIMATOR
39				ROBERTS

SCENE	FIELD	N.S.	E.W.	ANIMATOR

2 OVERLAYS WITH THIS BACKG'D

STANDING ON LOG

U.M. 27

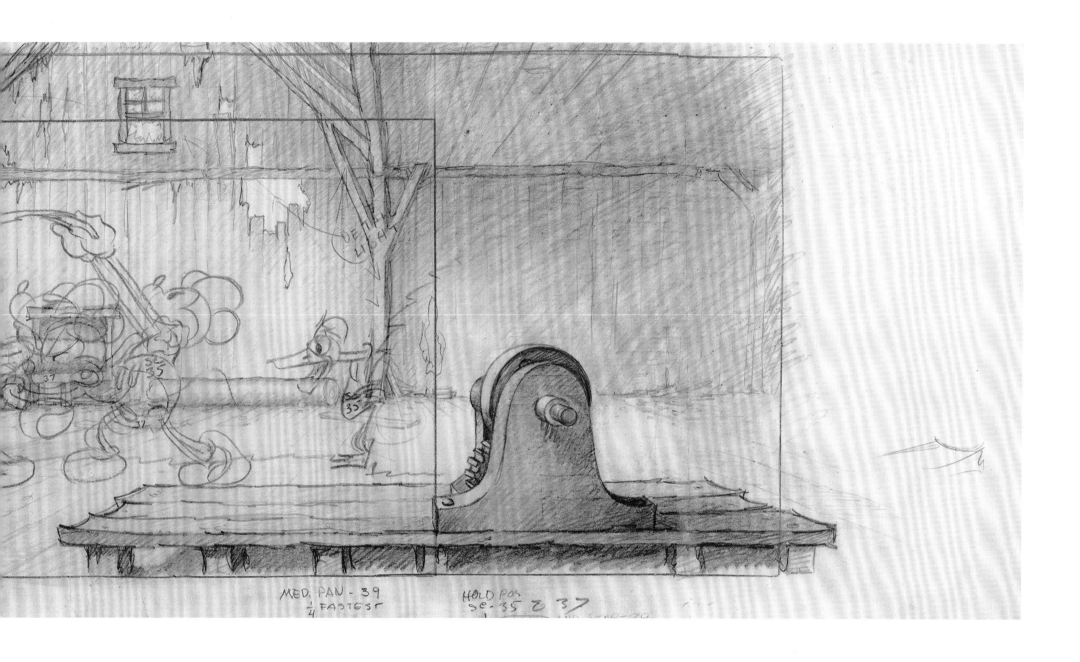

Disney Studio Artist. Layout drawing. *The Dognapper* (1934)
Graphite and colored pencil on paper | 9 x 34⅞ inches

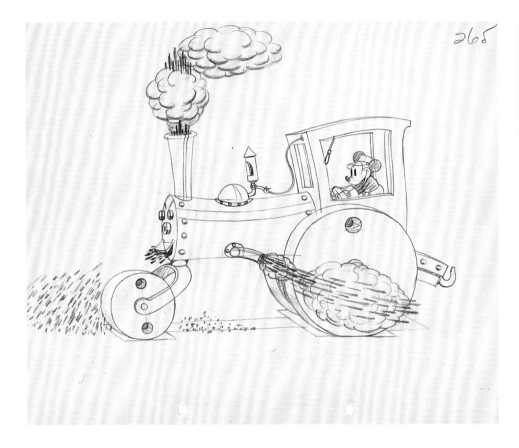

Johnny Cannon. Clean-up animation drawing. *Mickey's Steam Roller* (1934)
Graphite and colored pencil on paper | 9½ x 12 inches

Disney Studio Artists. Cel set-up. *Mickey's Steam Roller* (1934)
Ink and paint on cel and gouache on paper | 9½ x 11⅜ inches

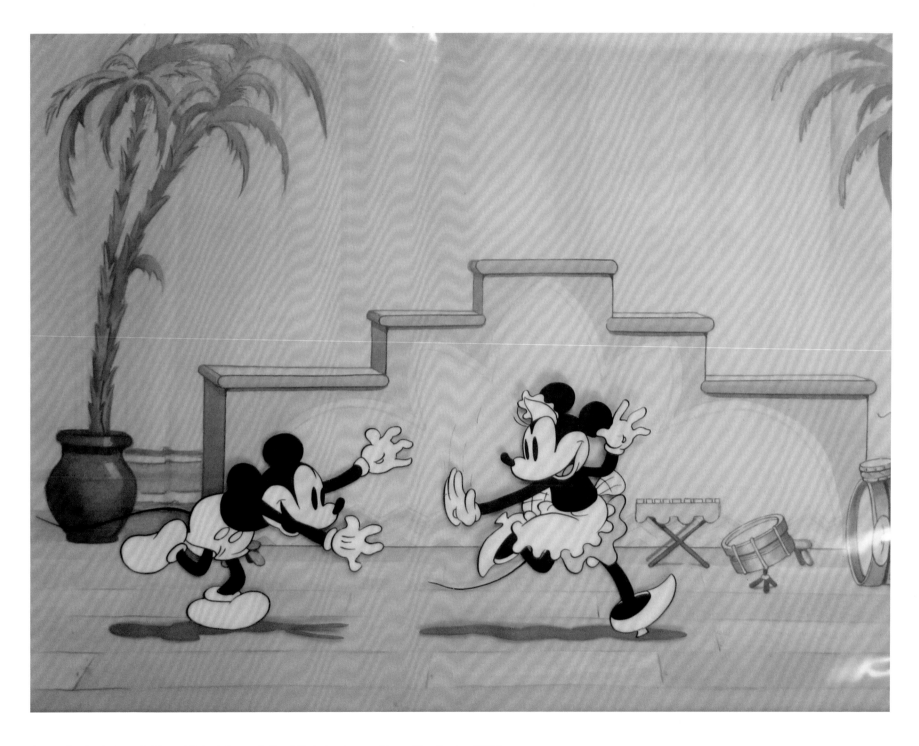

Disney Studio Artists. Cel from *Mickey's Steam Roller* (1934), background from *Blue Rhythm* (1931)
Paint on cel and gouache and graphite on paper | 9½ x 12 inches

Disney Studio Artist. Three sheet poster, c. 1933
Printed ink on paper | 79⅞ x 43¼inches

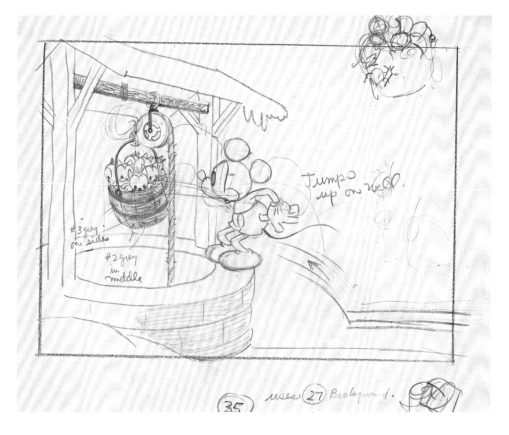

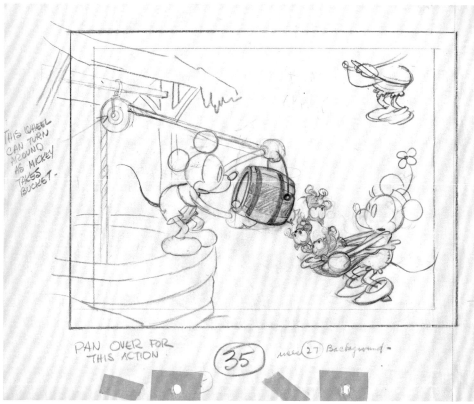

Les Clark. Layout drawing. *Mickey's Pal Pluto* (1933)
Graphite and colored pencil on paper | 9½ x 12 inches

Les Clark. Layout drawing. *Mickey's Pal Pluto* (1933)
Graphite and colored pencil on paper | 9½ x 12⅜ inches

"We felt that the public, and especially the children, like animals that are cute and little. I think we are rather indebted to Charlie Chaplin for the idea. We wanted something appealing, and we thought of a tiny bit of a mouse that would have something of the wistfulness of Chaplin—a little fellow trying to do the best he could."

—Walt

Disney Studio Artist. One sheet poster, 1935
Lithograph on paper | 41¼ x 27¾ inches

COLOR FILMS

BY THE TIME MICKEY MOUSE FIRST APPEARED in color to the theatergoing public, Walt Disney's studio had already experimented with Technicolor in the Silly Symphonies, a series of musical short films that debuted in 1929. When *The Band Concert* was reimagined and released in color in 1935, Mickey himself was also partially redesigned, giving him a more believable and lively appearance. At the time, this was considered Mickey's greatest performance, but it also marked the beginning of an end to his solo career: Mickey's character, tried and true, was cute and appealing but not always inherently funny. Walt and his staff recognized his unwavering charm and complemented him with a diverse cast of characters that could act as his foils. Among others, there was the cantankerous Donald Duck, the clumsy, aptly named Goofy, and the beloved and loyal dog Pluto, Mickey's best friend.

Following *The Band Concert*, the trio of Mickey, Donald, and Goofy would appear together on adventures audiences fell in love with, including *Mickey's Fire Brigade* (1935), *Moose Hunters* (1937), and *Clock Cleaners* (1937). Between 1938 and 1940, Mickey was at the peak of his superstardom. In 1938, *Brave Little Tailor*—adapted from the German fairy tale "The Valiant Little Tailor" (1640) and now considered one of the best and most entertaining Mickey shorts—was nominated for an Academy Award®.

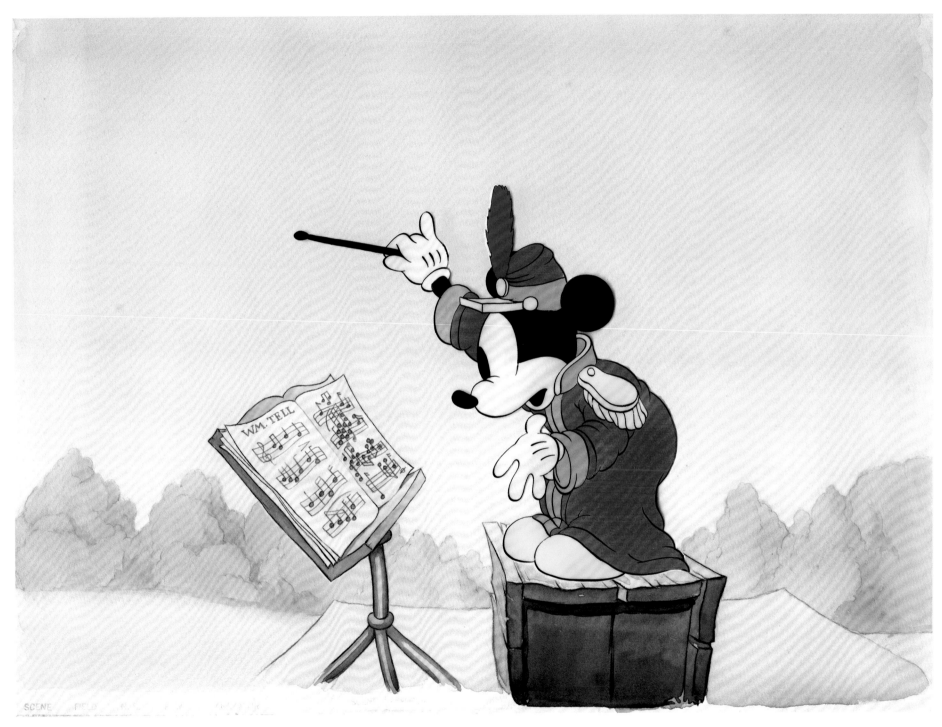

Disney Studio Artists. Cel and background painting. *The Band Concert* (1935)
Watercolor, ink, and graphite on paper, and ink and paint on cel | 10 x 12½ inches

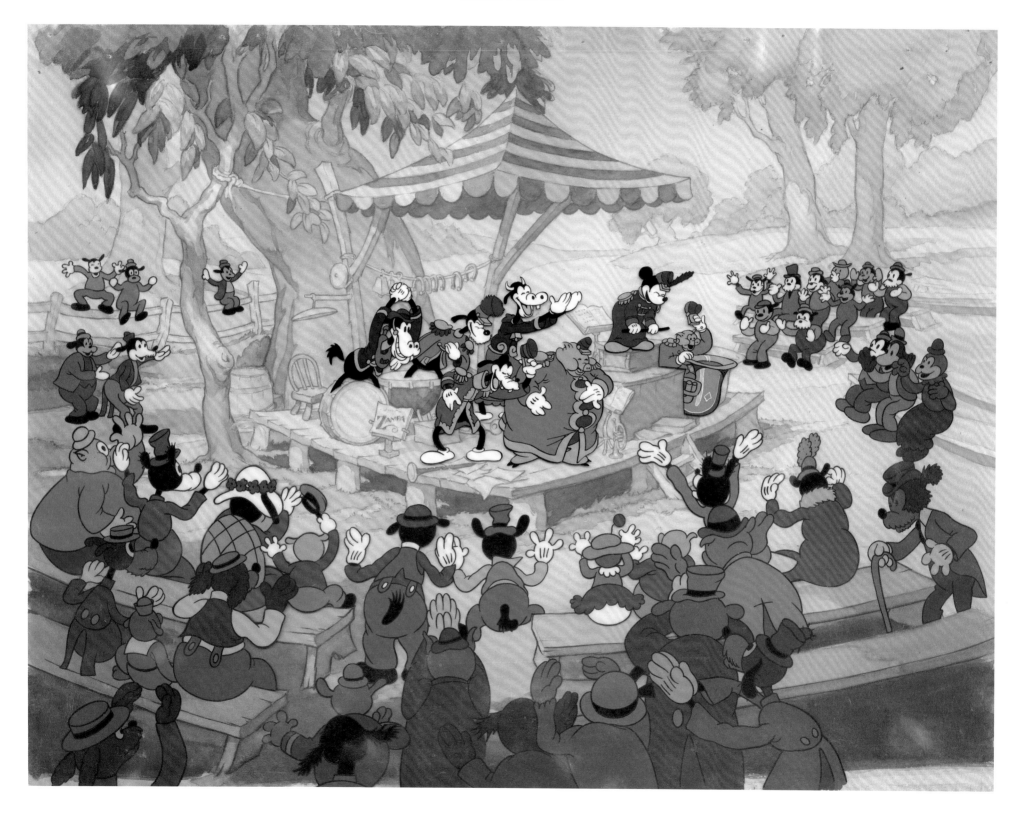

Disney Studio Artist. Layout drawings. *The Band Concert* (1935)
Graphite and colored pencil on paper | 9½ x 12 inches each

◄ Disney Studio Artists. Cel set-up. *The Band Concert* (1935)
Ink and paint on cel and gouache on paper | 10 x 12½ inches

Disney Studio Artists. Cel set-up. *Mickey's Fire Brigade (1935)*
Ink and paint on cel and gouache on paper | 10 x 12½ inches

Disney Studio Artist. Layout drawing. *Mickey's Service Station* (1935)
Graphite and colored pencil on paper | 9 x 42 inches

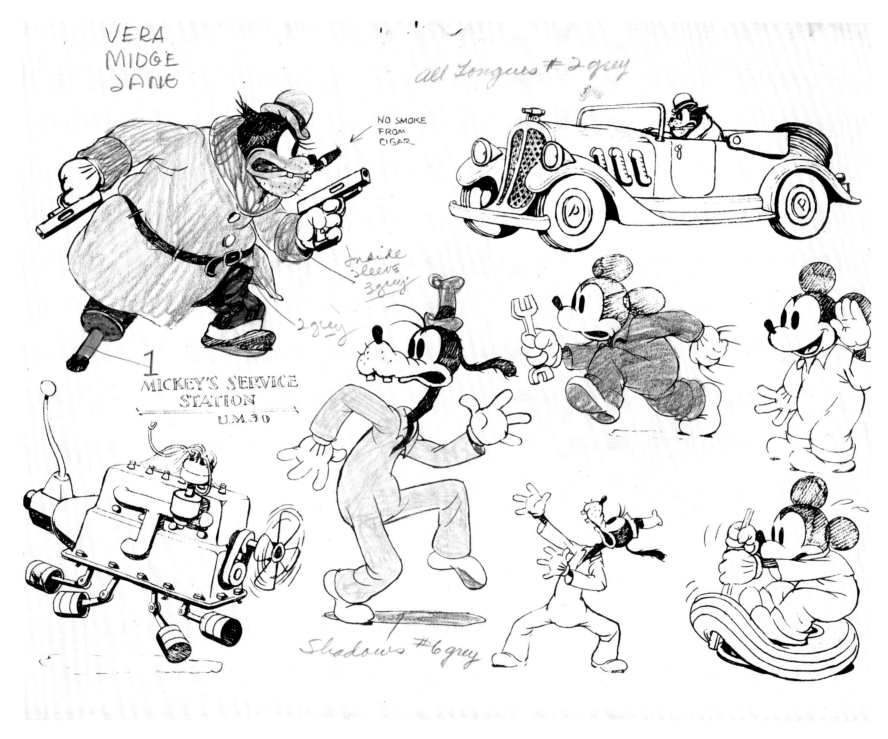

Disney Studio Artist. Model sheet. *Mickey's Service Station* (1935)
Graphite and colored pencil on paper | 9½ x 12 inches

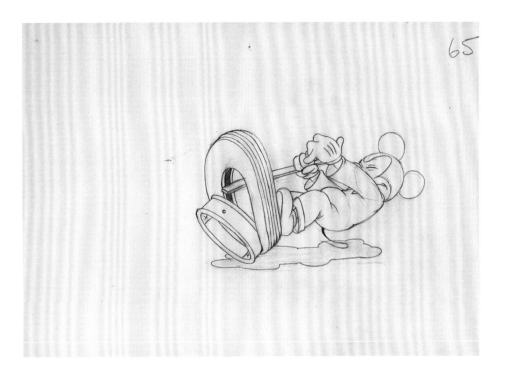

Jack Kinney. Clean-up animation drawings. *Mickey's Service Station* (1935)
Graphite and colored pencil on paper | 9½ x 12 inches each

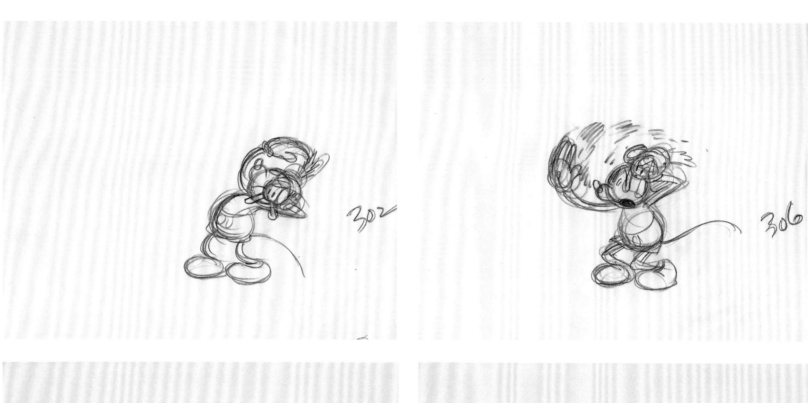

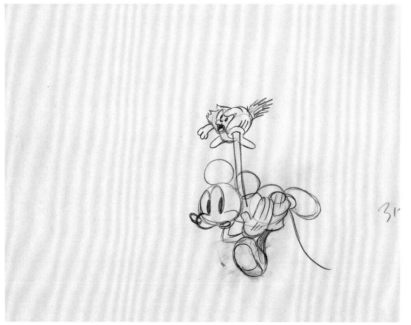

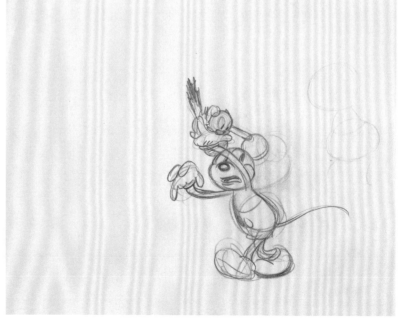

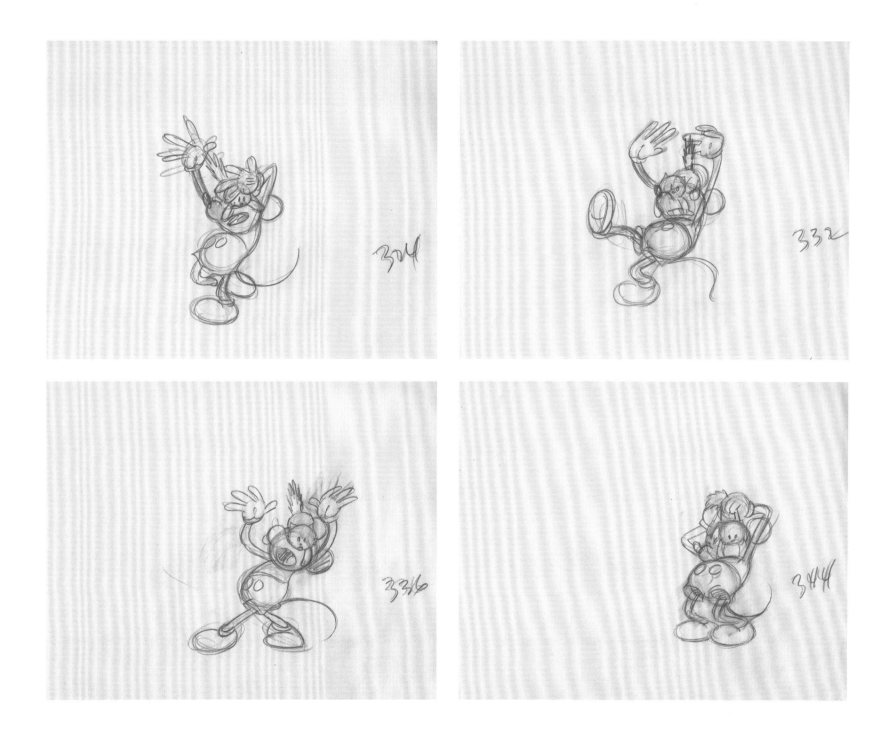

Fred Moore. Rough animation drawings. *Pluto's Judgement Day* (1935)
Graphite and colored pencil on paper | 9½ x 12 inches each

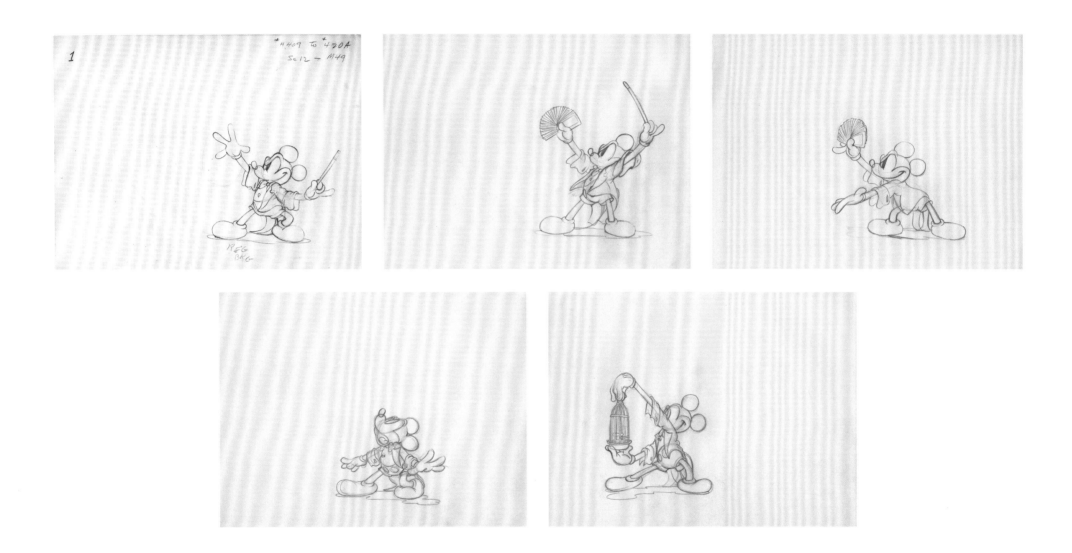

▲ Les Clark. Clean-up animation drawings. *Magician Mickey* (1937)
Graphite and colored pencil on paper | 10 x 12 inches each

opposite ▸ Bill Roberts. Clean-up animation drawing. *Magician Mickey* (1937)
Graphite and colored pencil on paper | 10 x 12 inches

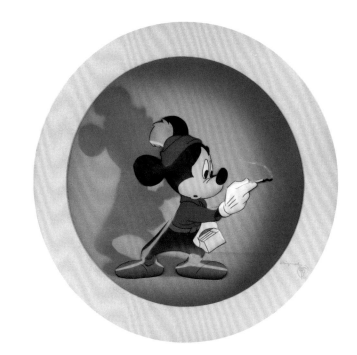

Disney Studio Artist. Clean-up animation drawing. *Mickey's Surprise Party* (1939)
Graphite and colored pencil on paper | 10 x 12 inches

▲ Disney Studio Artist. Background painting. *Squatter's Rights* (1946)
Gouache on paper | 10 x 12 inches

⬈ Disney Studio Artists. Courvoisier cel. *Squatter's Rights* (1946)
Paint on cel | 14½ x 13⅜ inches

▲ Disney Studio Artist. Background painting. *Tugboat Mickey* (1940)
Gouache on paper | 12 x 17 inches

Disney Studio Artists. Cel set-up. *The Nifty Nineties* (1941)
Paint on cel and gouache on paper | 13½ x 16⅛ inches

↟ Disney Studio Artist. Background painting. *Orphans' Benefit* (1941)
Gouache on paper | 10 x 12 inches

"PARDON US!"

Disney Studio Artist. Story sketch.
"Mickey and the Beanstalk" segment from *Fun and Fancy Free* (1947)
Ink and charcoal on paper | 8¾ x 8¼ inches

Disney Studio Artist. Background painting.
"Mickey and the Beanstalk" segment from *Fun and Fancy Free* (1947)
Gouache on paper | 10 x 12 inches

Disney Studio Artist. Concept art.
"Mickey and the Beanstalk" segment from *Fun and Fancy Free* (1947)
Gouache on paper | 6 x 7¾ inches

Disney Studio Artist. Concept art.
"Mickey and the Beanstalk" segment from *Fun and Fancy Free* (1947)
Gouache on paper | 5¼ x 7¾ inches

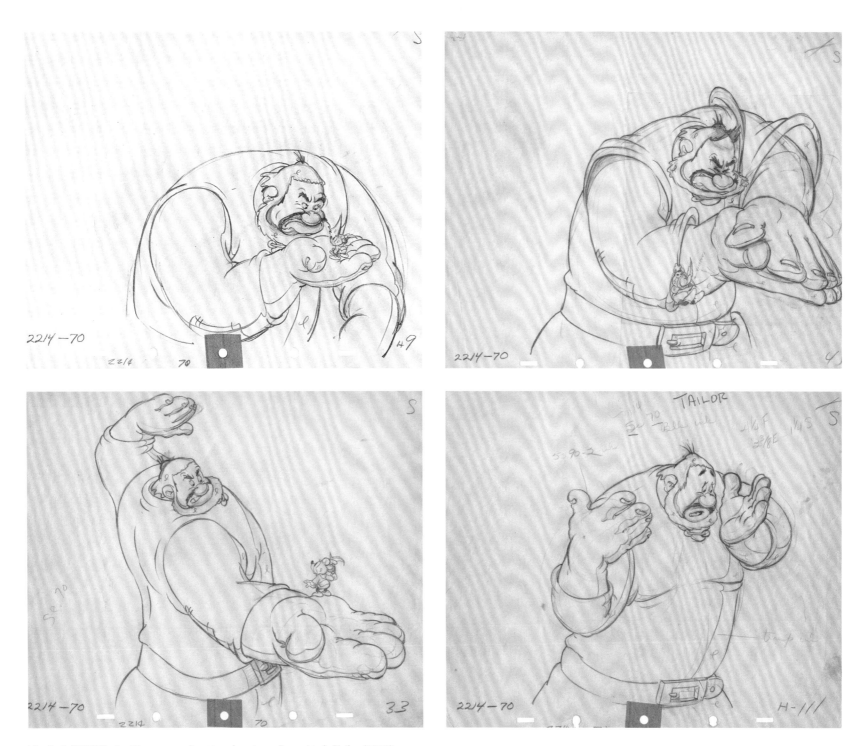

Vladimir "Bill" Tytla. Clean-up animation drawings. *Brave Little Tailor* (1938)
Graphite and colored pencil on paper | 10 x 12 inches each

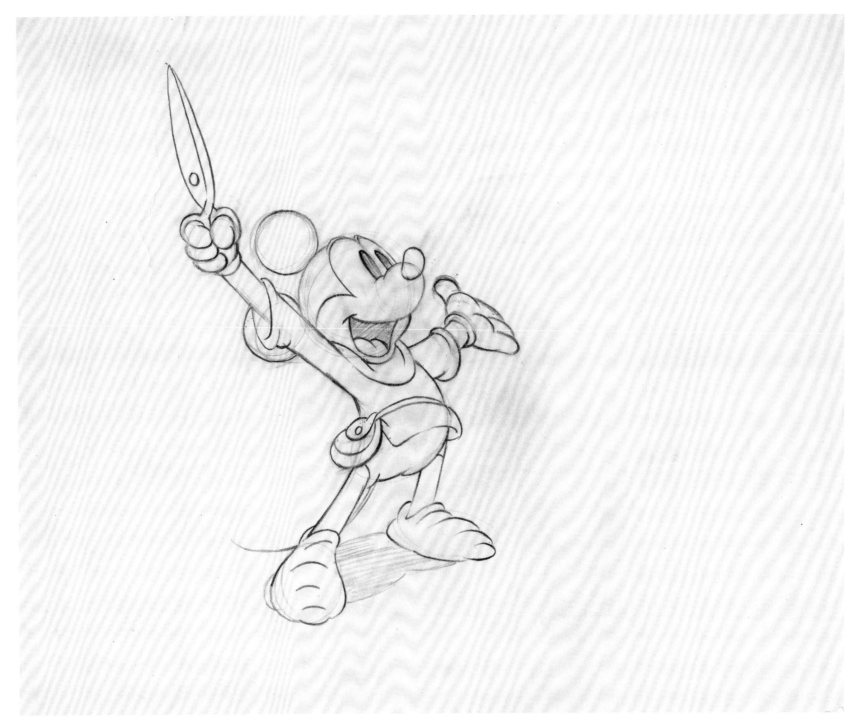

Frank Thomas. Clean-up animation drawing. *Brave Little Tailor* (1938)
Graphite and colored pencil on paper | 10 x 12 inches

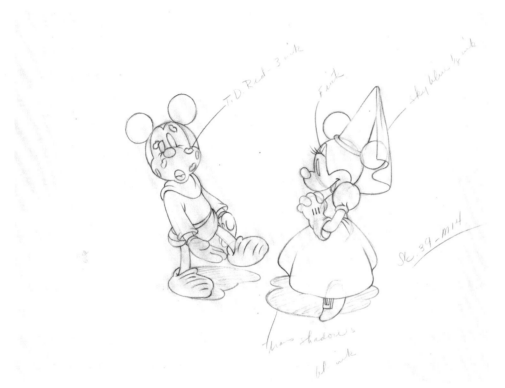
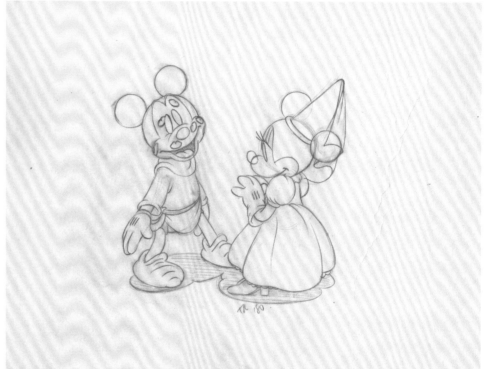

Frank Thomas. Clean-up animation drawings. *Brave Little Tailor* (1938)
Graphite and colored pencil on paper | 10 x 12 inches each

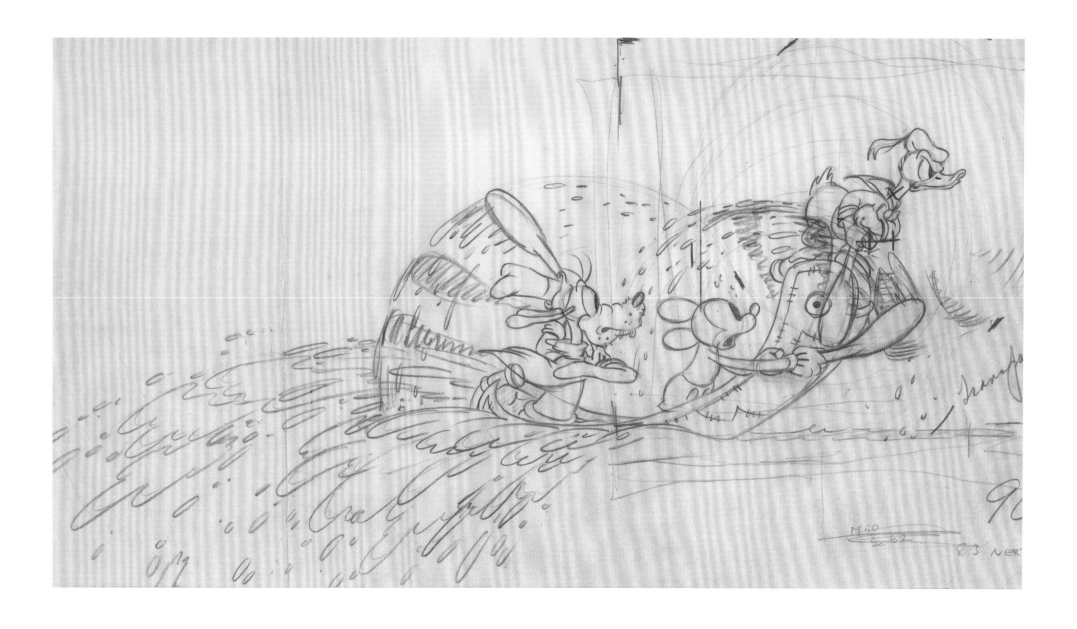

Disney Studio Artist. Layout drawing. *Moose Hunters* (1937)
Graphite and colored pencil on paper | 9⅞ x 17¾ inches

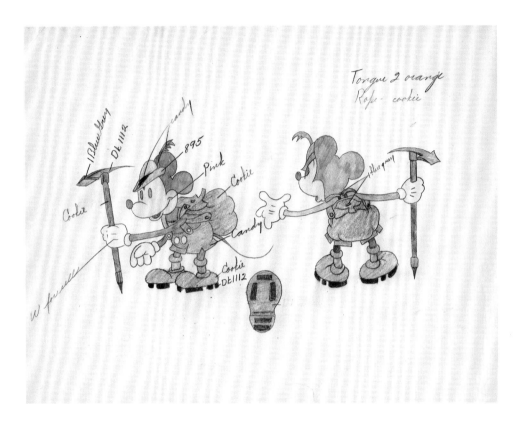

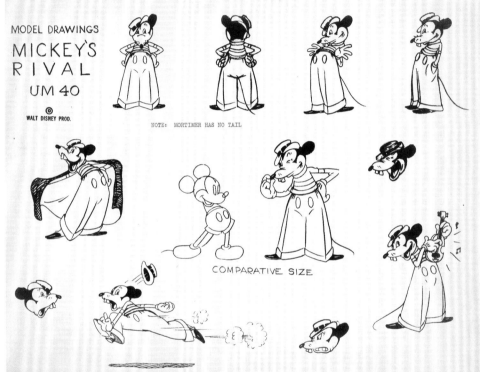

Disney Studio Artist. Color model drawing. *Alpine Climbers* (1936)
Colored pencil and graphite on paper | 10 x 12 inches

Disney Studio Artist. Model sheet. *Mickey's Rival* (1936)
Photostat on paper | 9½ x 12 inches

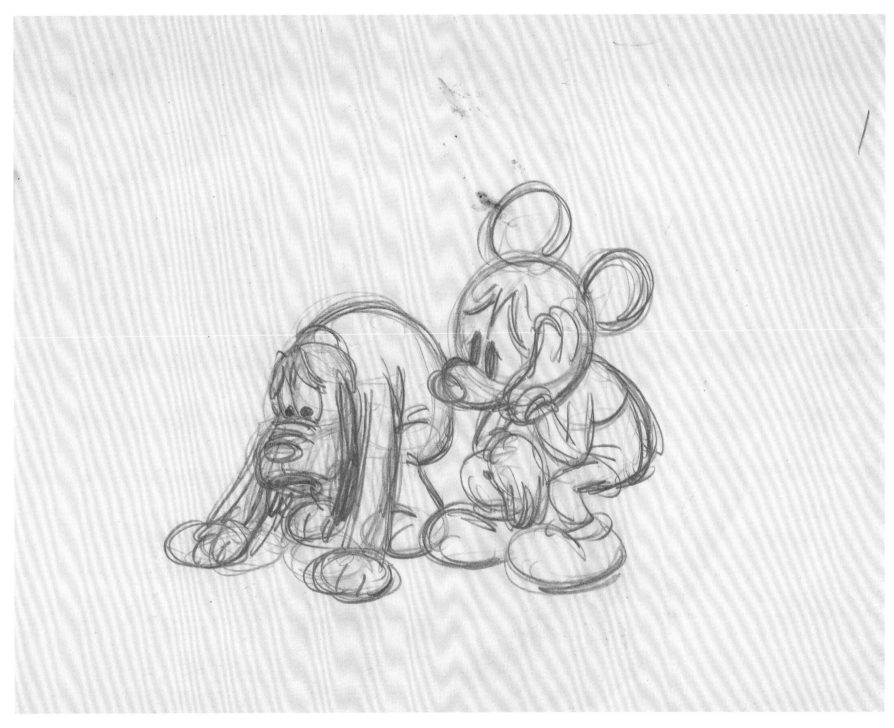

Fred Moore. Rough animation drawing. *Society Dog Show* (1939)
Graphite and colored pencil on paper | 10 x 12 inches

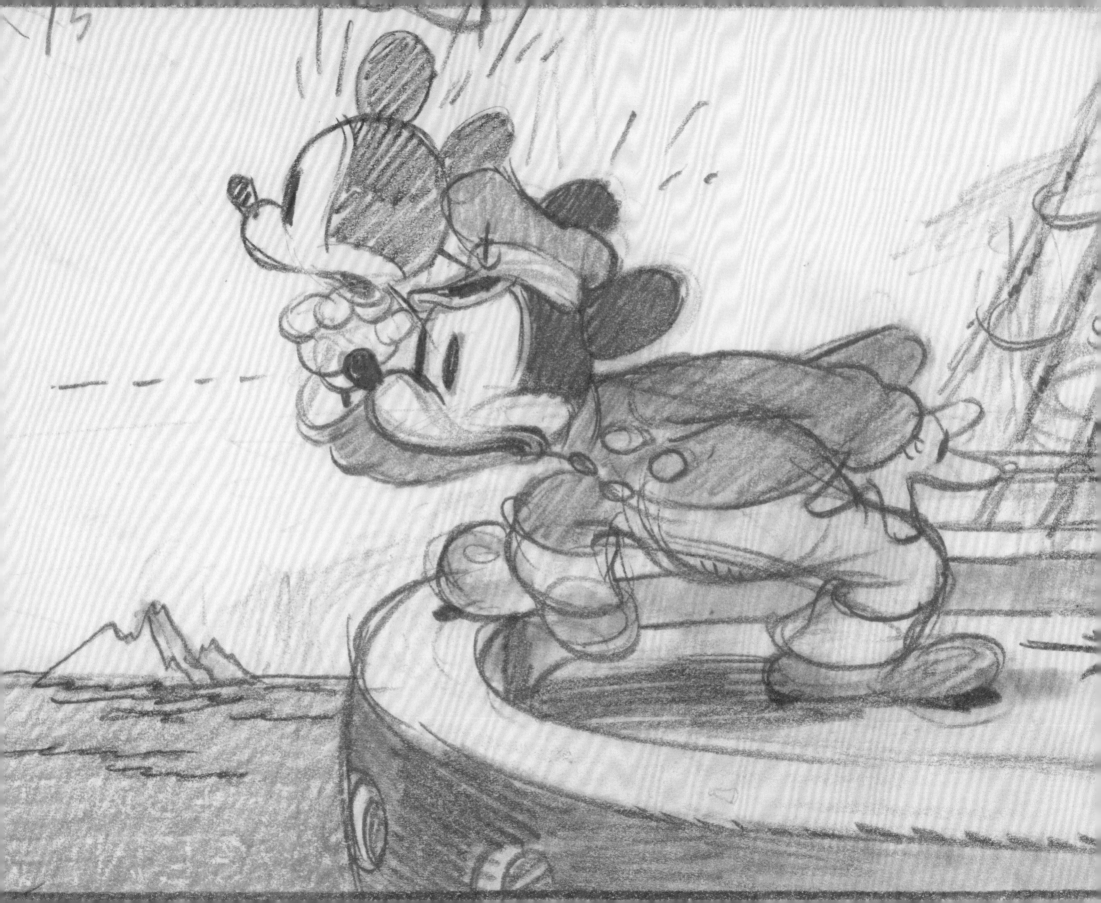

◄ Disney Studio Artist. Layout drawing. *The Whalers* (1938)
Colored pencil and graphite on paper | 6½ x 8¼ inches

▲ Fred Moore. Clean-up animation drawings. *Mickey's Rival* (1936)
Graphite and colored pencil on paper | 10 x 12 inches each

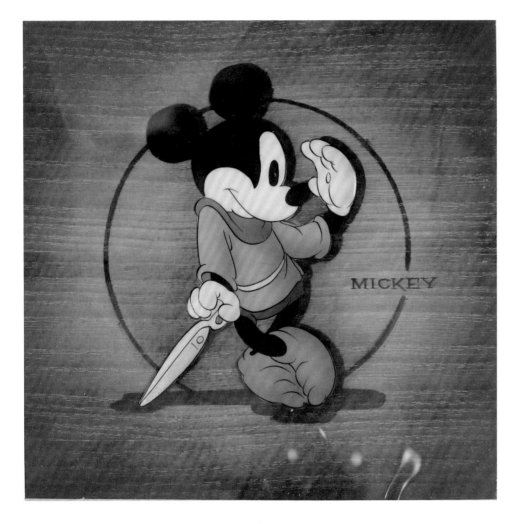

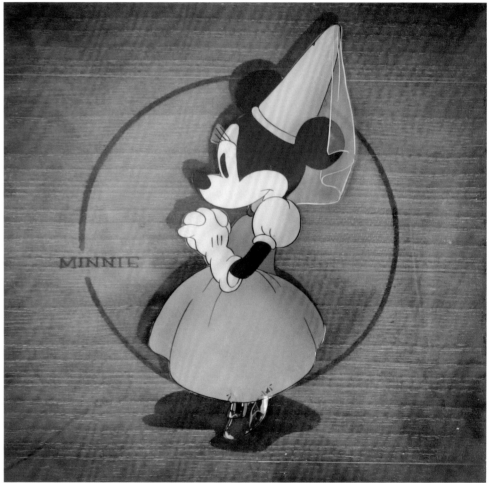

▲ Disney Studio Artists. Cel set-ups. *Brave Little Tailor* (1938)
Paint on cel and pyrography on wood | 7 x 6¾ inches each

opposite ▶ Disney Studio Artist. Layout drawing. *Mickey's Parrot* (1938)
Colored pencil and graphite on paper | 10 x 12 inches

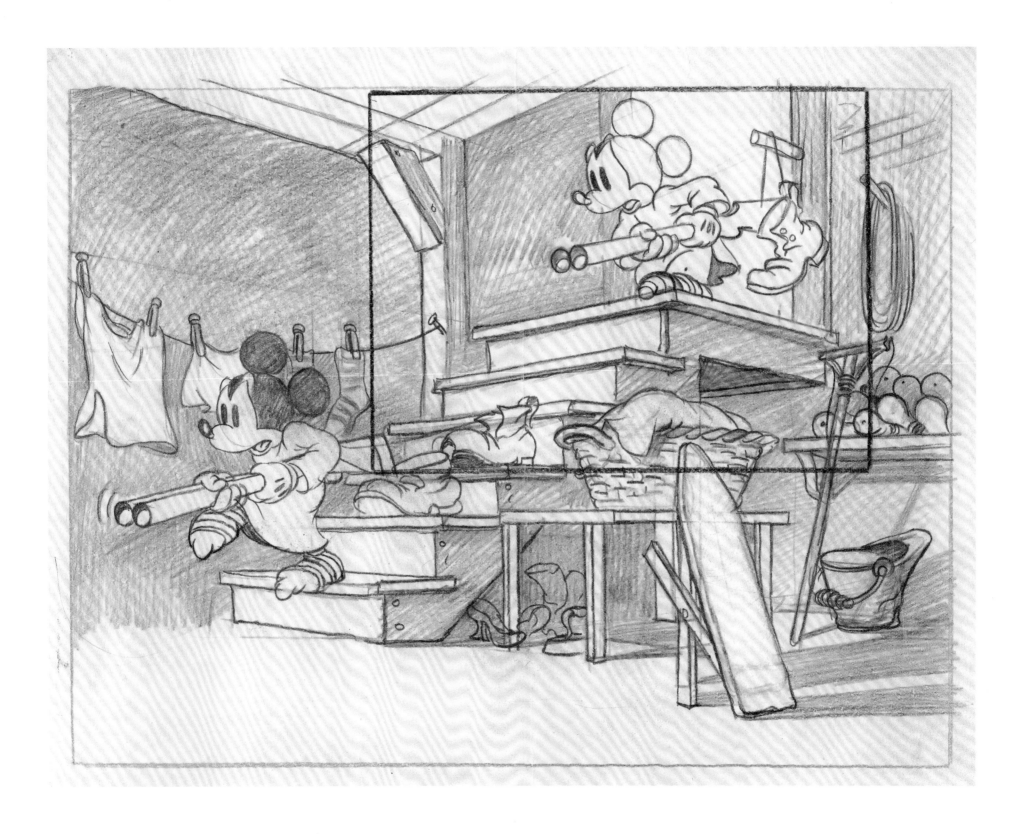

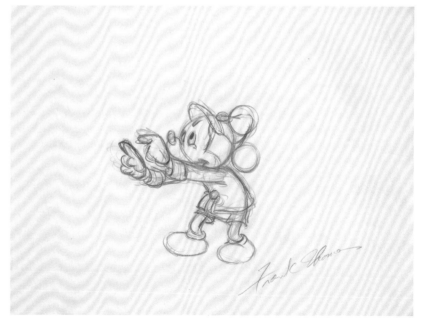

Frank Thomas. Rough animation drawings. *The Pointer* (1939)
Graphite and colored pencil on paper | 10 x 12 inches each

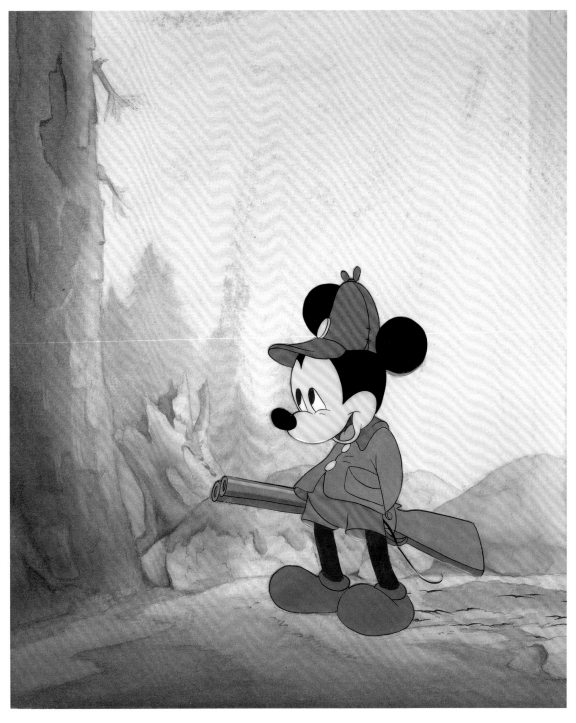

Disney Studio Artists. Cel set-up. *The Pointer* (1939)
Ink and paint on cel and gouache on paper | 9¼ x 7⅝ inches

"When people laugh at Mickey Mouse it's because he's so human; and that is the secret of his popularity."

—Walt

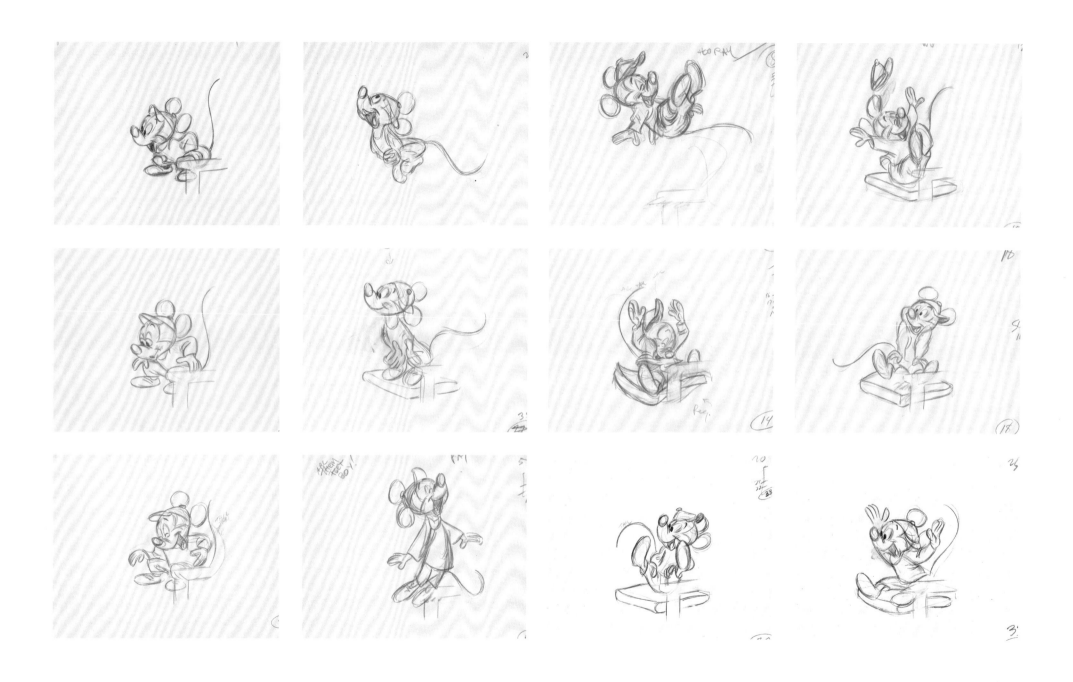

Fred Moore. Rough animation drawings. *Pluto Plays Football* (unproduced, c. 1952)
Graphite and colored pencil on paper | 10 x 12 inches each

THE DESIGN OF MICKEY

STARTING WITH HIS INITIAL APPEARANCE and throughout his early years, Mickey Mouse clearly resembled Oswald the Lucky Rabbit. Though Mickey had a different nose, tail, and ears, one could still see the hands of Oswald's creators, Walt and Ub Iwerks. Initially, Iwerks wanted to make Mickey easy to animate, so he composed the character with circles. He would later add white gloves, which made Mickey's gestures easier to read, offset by his black body. His ears were drawn as complete circles that didn't change shape no matter which way Mickey turned his head, defying all laws of perspective. Animator Marc Davis and others believed that the simple shapes not only made the character's movements more dynamic but added to his appeal as well.

During the late 1930s, animator Fred Moore transformed Mickey's body from circular to pear-shaped. This design allowed Mickey to express more emotion, creating space for movement within his inflating and deflating chest—animating elation or dejection. Moore was nervous about the changes, but, when Walt saw the results, he enthusiastically approved. From then on, Mickey was to be drawn and animated in this new fashion. The "rubber hose" limbs were phased out and replaced by more humanlike anatomy. Mickey became more boyish in style and movement—less like Charlie Chaplin and more like a popular child actor from that time, Mickey Rooney.

In his earliest films, Mickey's eyes were black and oval-shaped. They later morphed into small dark pupils with white around them, allowing for more pleasing expressions and subtle acting, since he could direct his gaze. Finally, with Fred Moore's makeover, Mickey received more realistic eyes, while his facial skin tone became an off-white shade, later shifting to a soft pink. A pair of snappy red shorts with two buttons on the front, gloves, and shoes completed what is now the iconic look of Mickey Mouse.

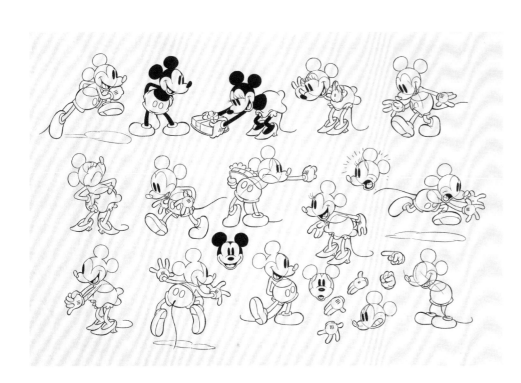

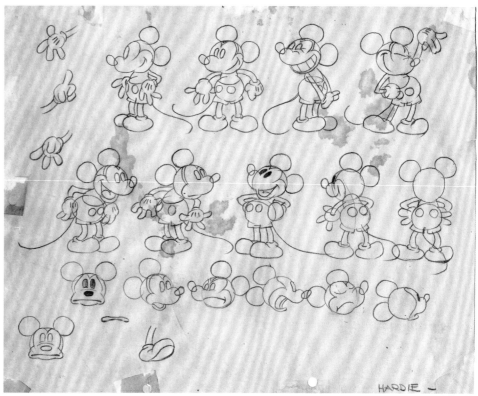

Les Clark. Model sheet. *Puppy Love* (1933)
Printed ink on paperboard | 15 x 21⅞ inches

Hardie Gramatky. Model sheet, c. 1931
Graphite on paper | 9½ x 12 inches

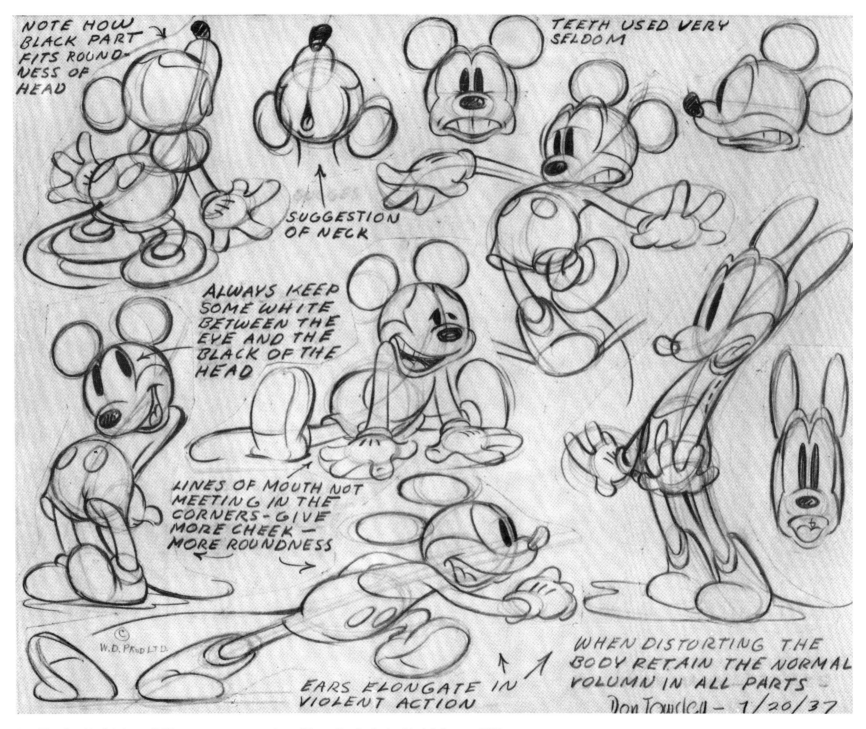

Don Towsley. Model sheet, 1937
Photostat on paper | 10 x 12½ inches

opposite ▸ Disney Studio Artist. Model sheet, c. 1930
Ink and colored pencil on paper | 9¾ x 11½ inches

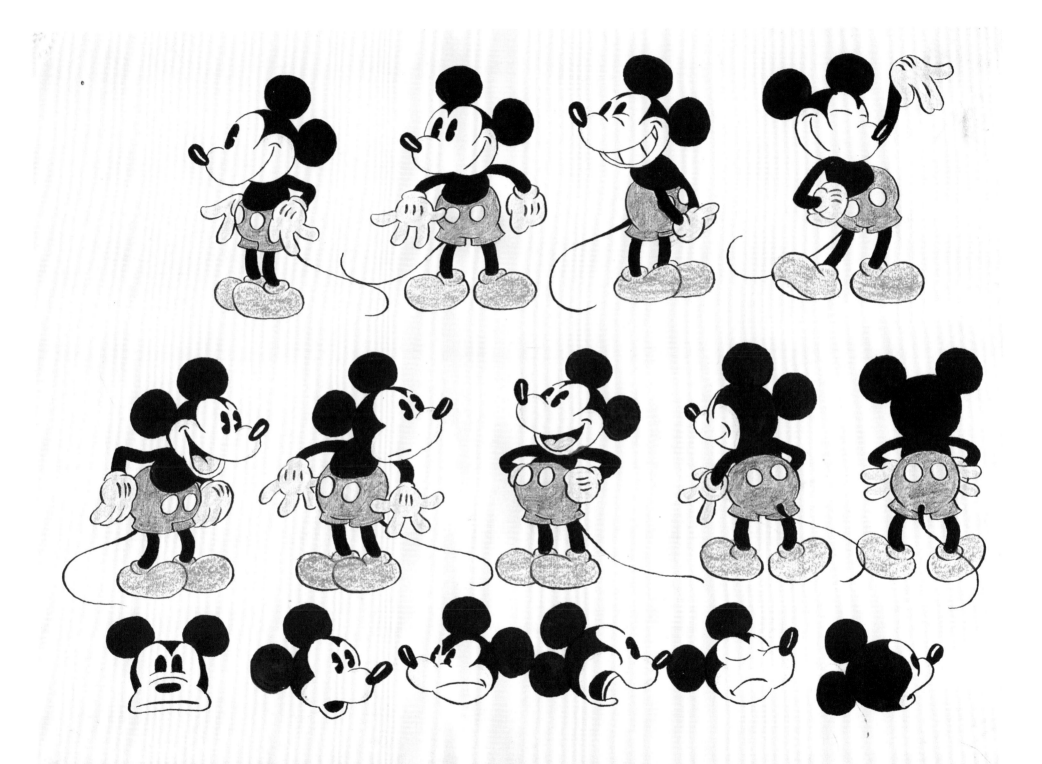

THE SORCERER'S APPRENTICE

WALT DECLARED THAT THE LIFE and ventures of his mouse star were closely bound up with his own personal and professional life. With this in mind, historians have speculated about the reasons why Mickey's popularity waned in the late 1930s. While it could have been simply due to the rising popularity of his costars, some historians believe there was a softening of Mickey's character, which made it difficult for animators to create gags that would suit his personality. A third explanation is summed up in a quote from animator Frank Thomas, who said, "Mickey was Walt, and Walt was Mickey." Perhaps because Walt's attention was elsewhere— on projects such as *Snow White and the Seven Dwarfs* (1937)— Mickey was missing an essential element.

In an attempt to revive Mickey's popularity, Walt created a leading role for him in "The Sorcerer's Apprentice," a two-reel film with classical music but no dialogue. It was originally conceived as a standalone short but became too costly to release theatrically in that format. By chance, while dining in Beverly Hills, Walt met Leopold Stokowski, who had directed the Philadelphia Orchestra since 1932. This meeting led to a collaboration that would mark a unique and innovative approach to combining classical music with personality animation. The short cartoon later evolved into the full-length feature film *Fantasia* (1940), which contained several animated segments, all set to music. "The Sorcerer's Apprentice" segment would ultimately stand out from the others for its charm and appeal, enough so that nearly 60 years later it would be the only original sequence from *Fantasia* to carry through to the sequel, *Fantasia/2000*.

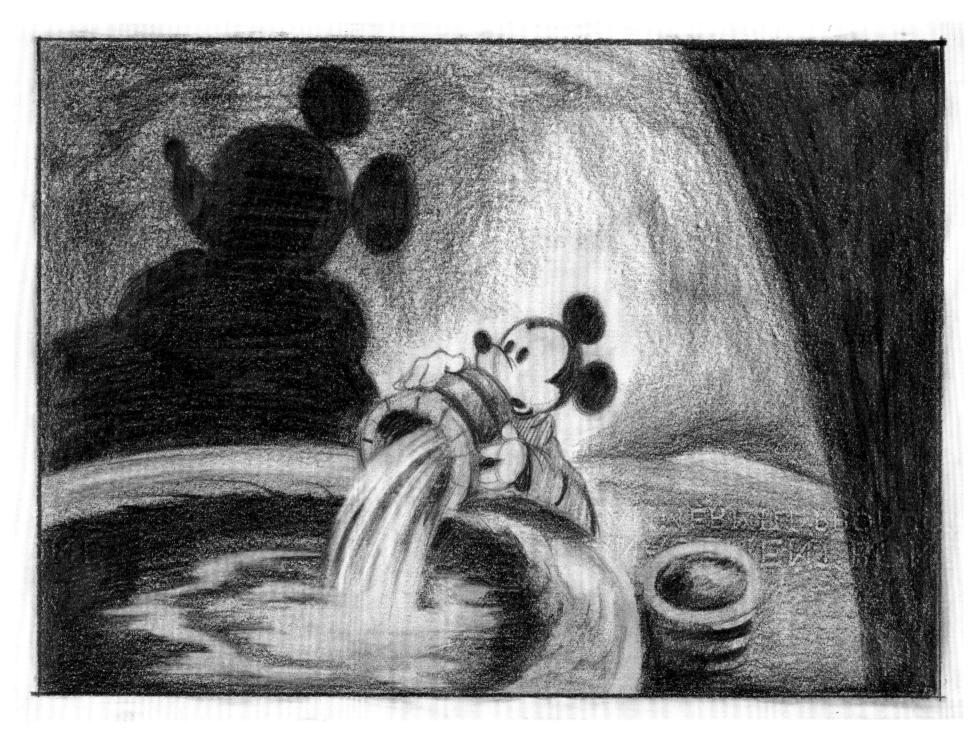

Disney Studio Artist. Concept art. "The Sorcerer's Apprentice" segment from *Fantasia* (1940)
Graphite on paper | 10 x 12 inches

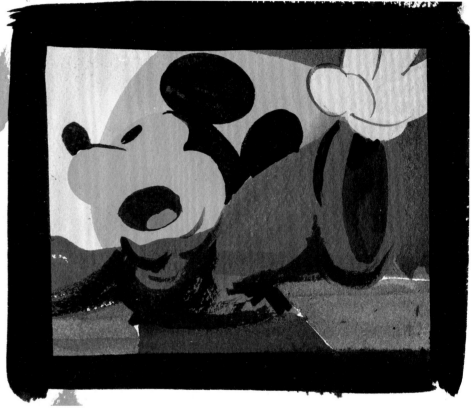

Disney Studio Artists. Story sketches. "The Sorcerer's Apprentice" segment from *Fantasia* (1940)
Colored pencil on paper | 12 x 10 inches each

Disney Studio Artist. Storyboard painting. "The Sorcerer's Apprentice" segment from *Fantasia* (1940)
Gouache on paper | 6¼ x 9 inches

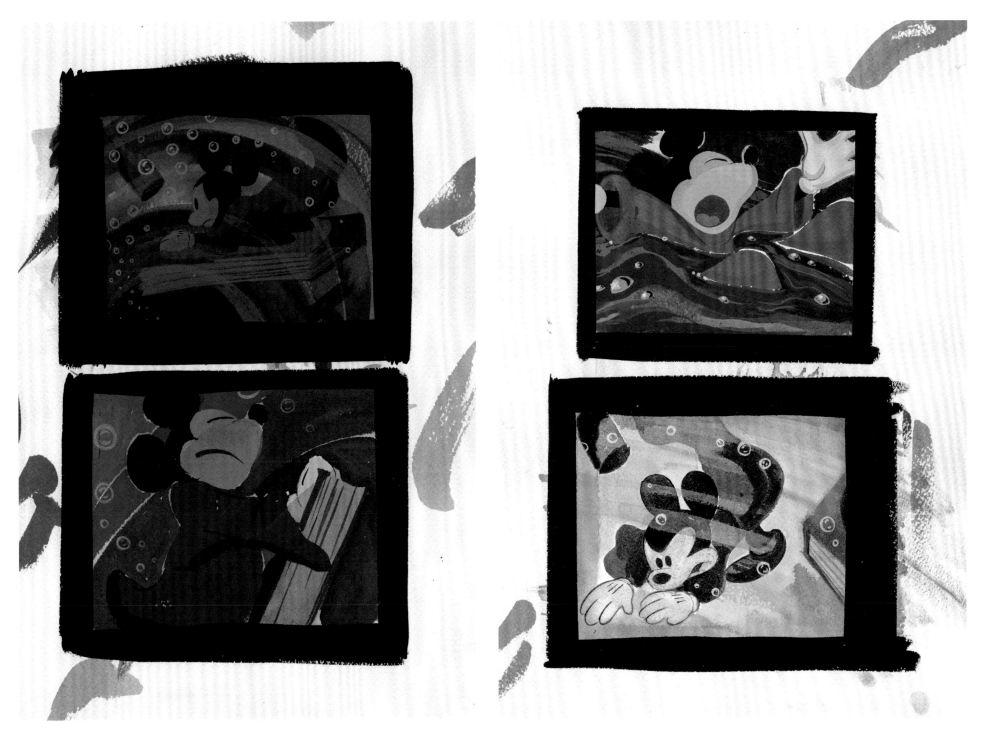

Disney Studio Artists. Storyboard paintings. "The Sorcerer's Apprentice" segment from *Fantasia* (1940)
Gouache on paper | 12 x 9 inches each

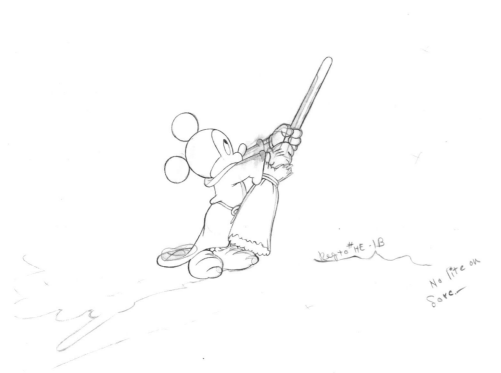

Vladimir "Bill" Tytla. Clean-up animation drawing.
"The Sorcerer's Apprentice" segment from *Fantasia* (1940)
Graphite and colored pencil on paper | 10 x 12 inches

Disney Studio Artist. Rough animation drawing.
"The Sorcerer's Apprentice" segment from *Fantasia* (1940)
Graphite and colored pencil on paper | 10 x 12 inches

Fred Moore. Rough animation drawing. "The Sorcerer's Apprentice" segment from *Fantasia* (1940)
Graphite and colored pencil on paper | 12½ x 15⅜ inches

Fred Moore. Rough animation drawing.
"The Sorcerer's Apprentice" segment from *Fantasia* (1940)
Graphite and colored pencil on paper | 10 x 12 inches

Fred Moore. Rough animation drawing.
"The Sorcerer's Apprentice" segment from *Fantasia* (1940)
Graphite and colored pencil on paper | 10 x 12 inches

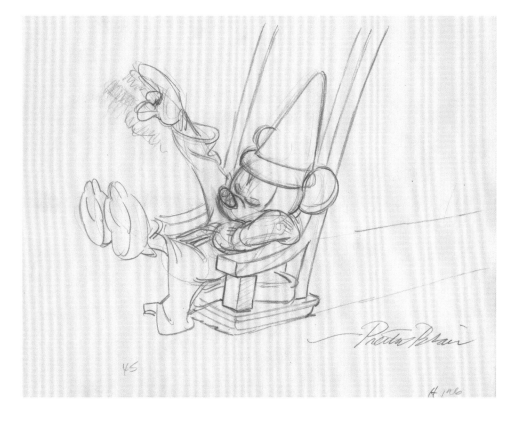 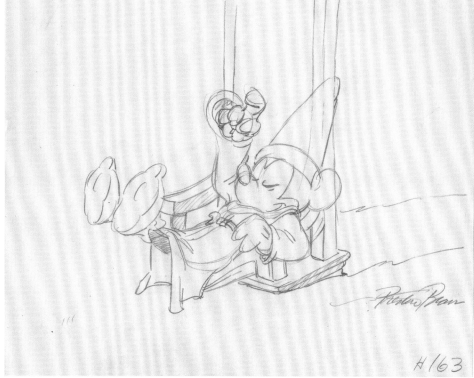

Preston Blair. Rough animation drawings. "The Sorcerer's Apprentice" segment from *Fantasia* (1940)
Graphite on paper | 10 x 12 inches each

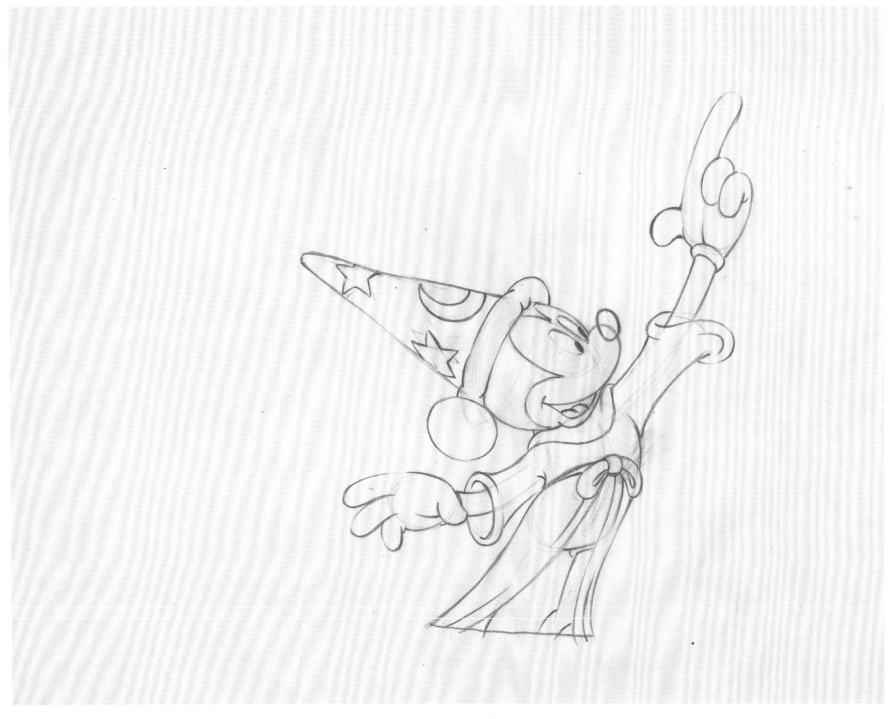

Riley Thomson. Clean-up animation drawing. "The Sorcerer's Apprentice" segment from *Fantasia* (1940)
Graphite on paper | 10 x 12 inches

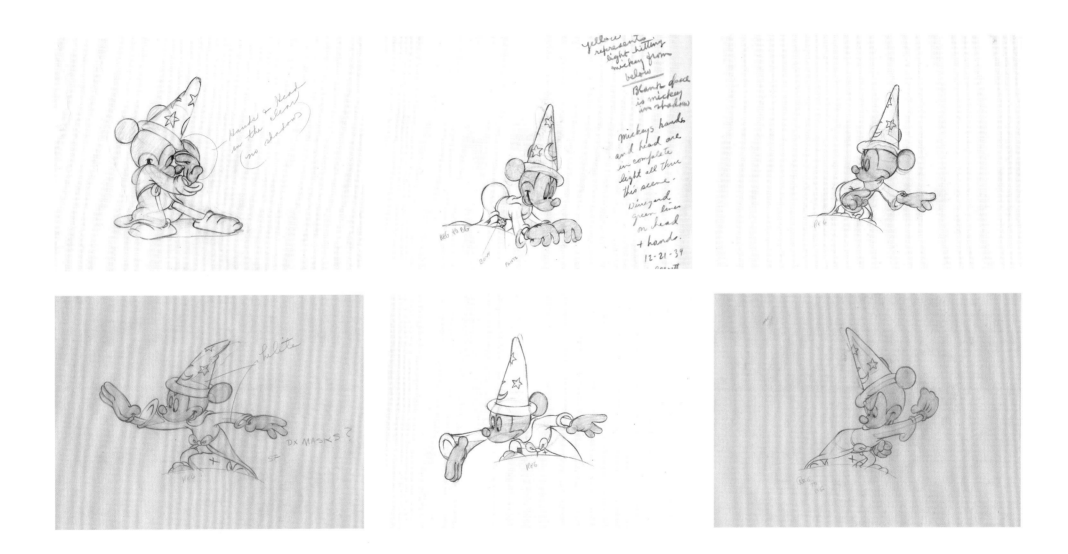

Riley Thomson. Clean-up animation drawings. "The Sorcerer's Apprentice" segment from *Fantasia* (1940)
Graphite and colored pencil on paper | 12½ x 15½ inches each (Drawing upper left 10 x 11¾ inches)

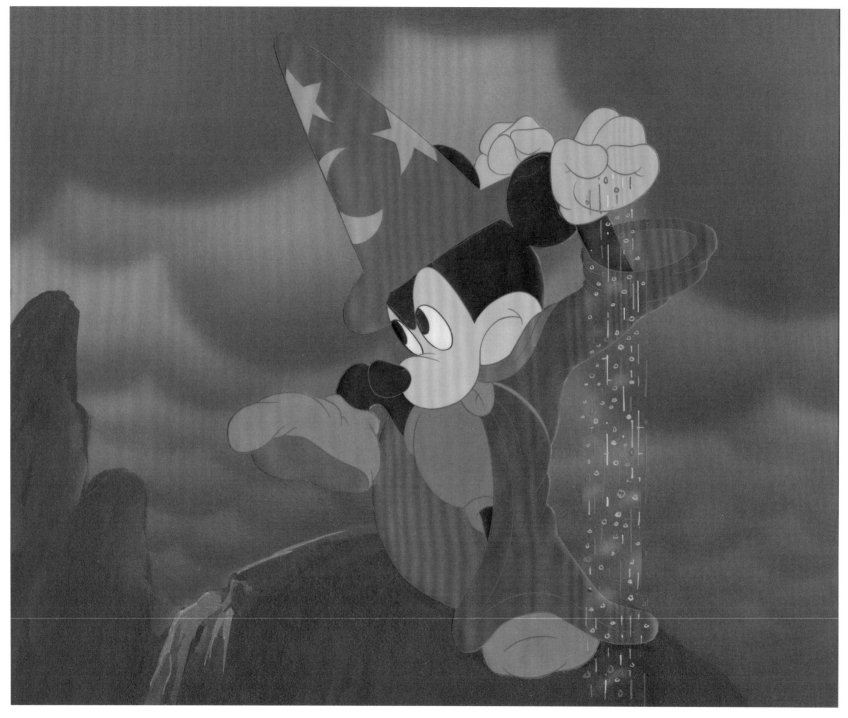

Disney Studio Artists. Cel set-up. "The Sorcerer's Apprentice" segment from *Fantasia* (1940)
Ink and paint on cel and gouache on paper　|　14⅞ x 15½ inches

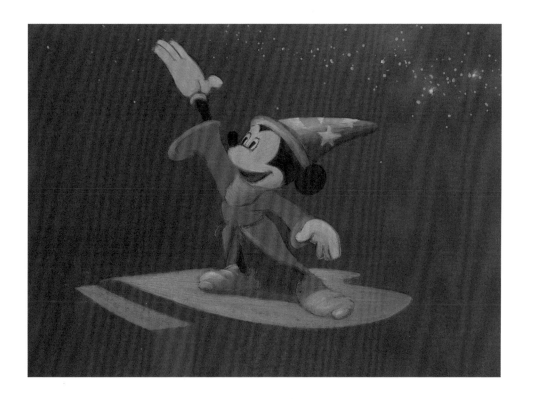

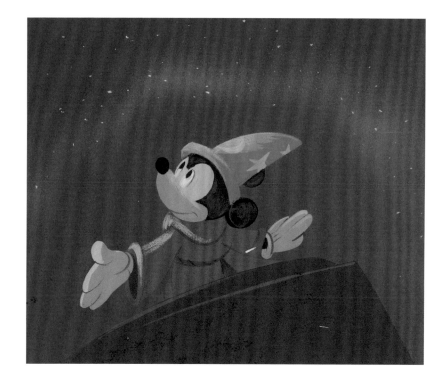

Disney Studio Artist. Concept art. "The Sorcerer's Apprentice" segment from *Fantasia* (1940)
Gouache on board | 6⅞ x 8½ inches

Disney Studio Artist. Concept art. "The Sorcerer's Apprentice" segment from *Fantasia* (1940)
Gouache on board | 6 x 7⅛ inches

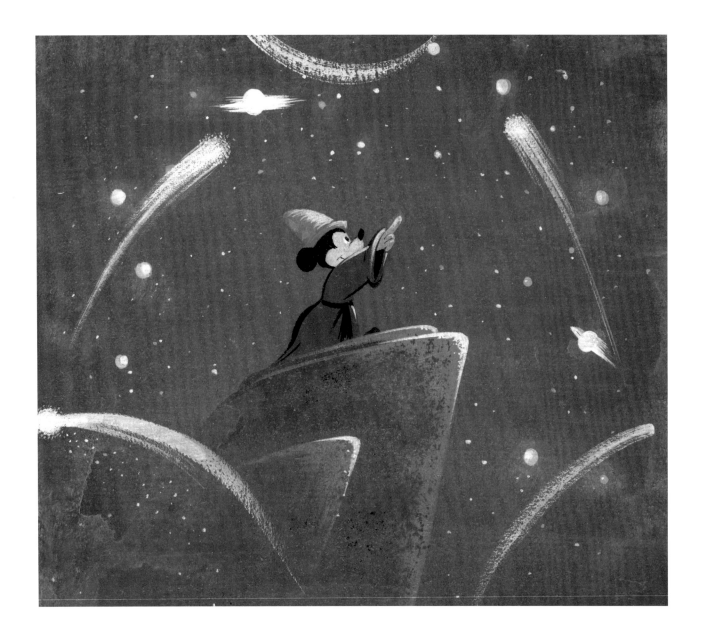

Disney Studio Artist. Concept art. "The Sorcerer's Apprentice" segment from *Fantasia* (1940)
Gouache on board | 6¼ x 7⅛ inches

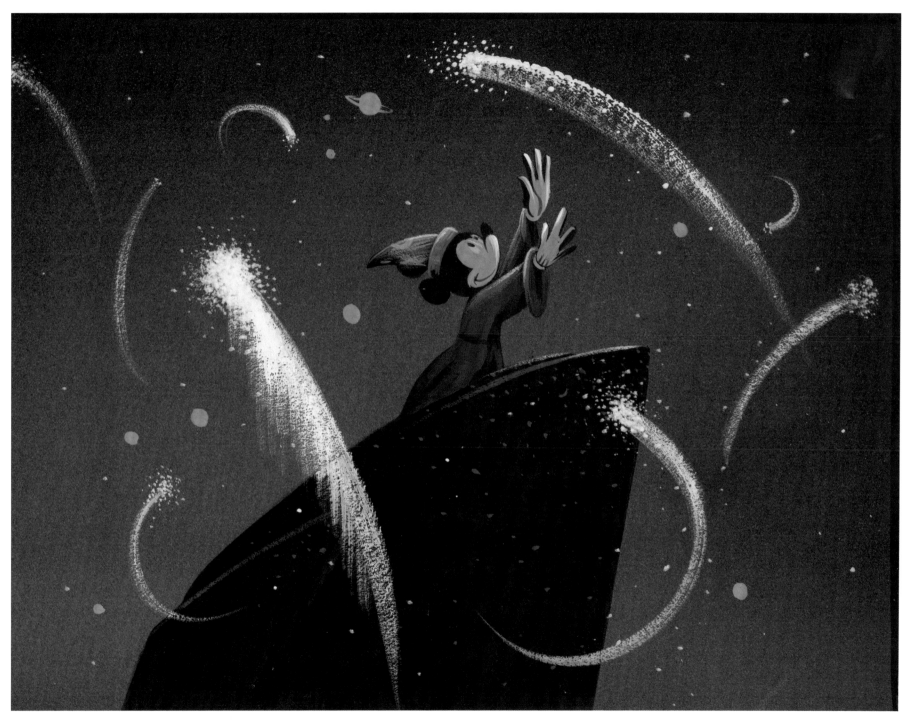

Disney Studio Artist. Concept art. "The Sorcerer's Apprentice" segment from *Fantasia* (1940)
Gouache on board | 7¼ x 9¼ inches

MICKEY CONVERTS A
RAGING WATERFALL
INTO FALLING SNOW

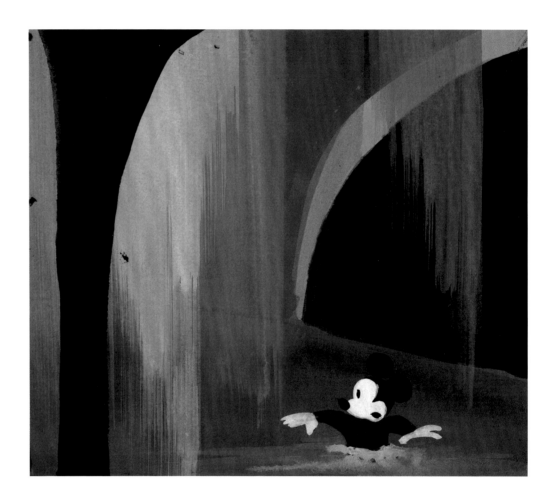

▲ Disney Studio Artist. Concept art. "The Sorcerer's Apprentice" segment from *Fantasia* (1940)
Gouache on paper | 5 x 5⅝ inches

◄ John Hubley. Concept art. "The Sorcerer's Apprentice" segment from *Fantasia* (1940)
Gouache on paper | 21½ x 4⅞ inches

THE SORCERER'S APPRENTICE

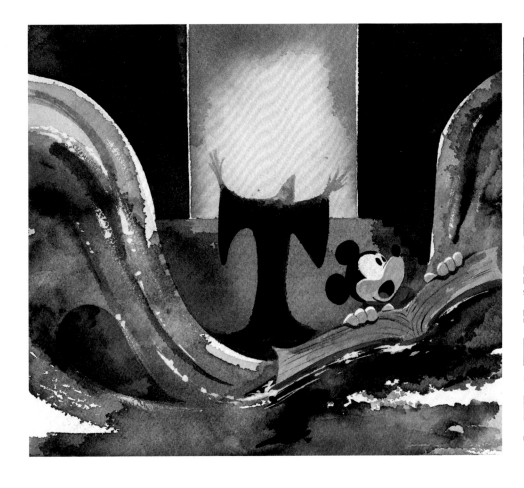

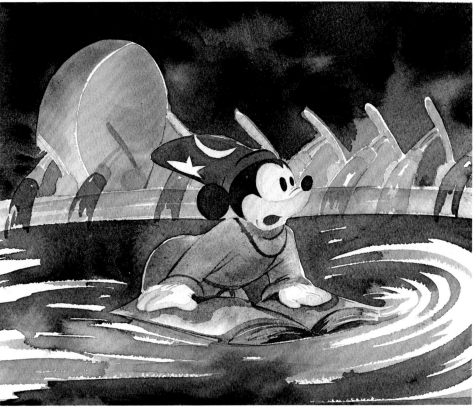

Disney Studio Artist. Concept art. "The Sorcerer's Apprentice" segment from *Fantasia* (1940)
Gouache on paper | 9 x 9⅞ inches

Disney Studio Artist. Concept art. "The Sorcerer's Apprentice" segment from *Fantasia* (1940)
Gouache on paper | 10 x 12 inches

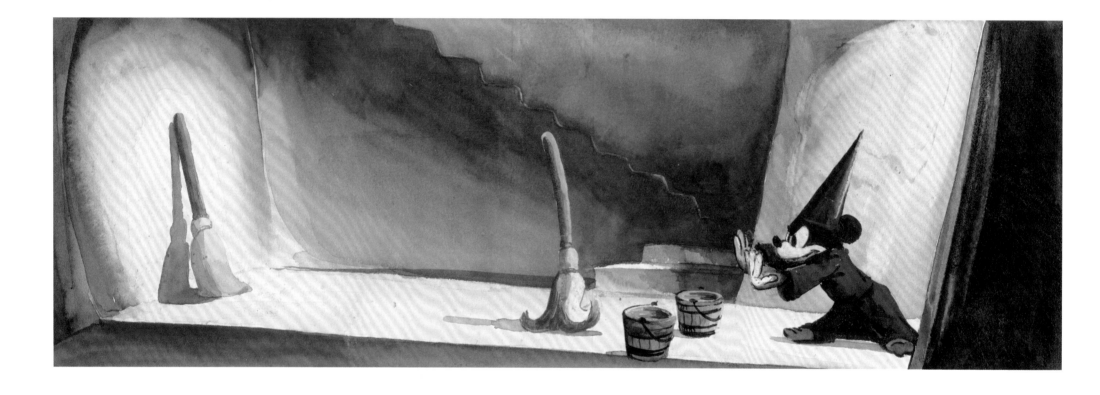

Tom Codrick. Concept art. "The Sorcerer's Apprentice" segment from *Fantasia* (1940)
Gouache on paper | 4½ x 12¾ inches

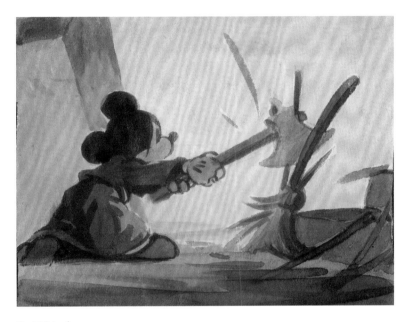

6 x 7¼ inches

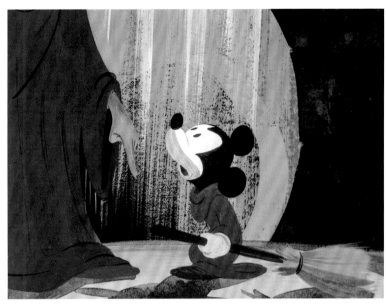

6½ x 7⅜ inches

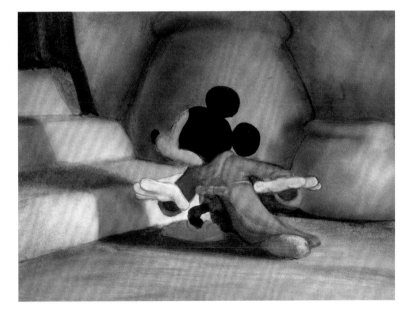

7 x 8½ inches

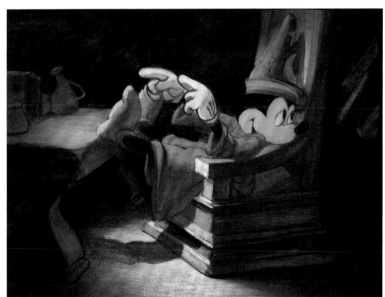

7 x 8½ inches

Disney Studio Artists. Concept art. "The Sorcerer's Apprentice" segment from *Fantasia* (1940)
Gouache on paper and board

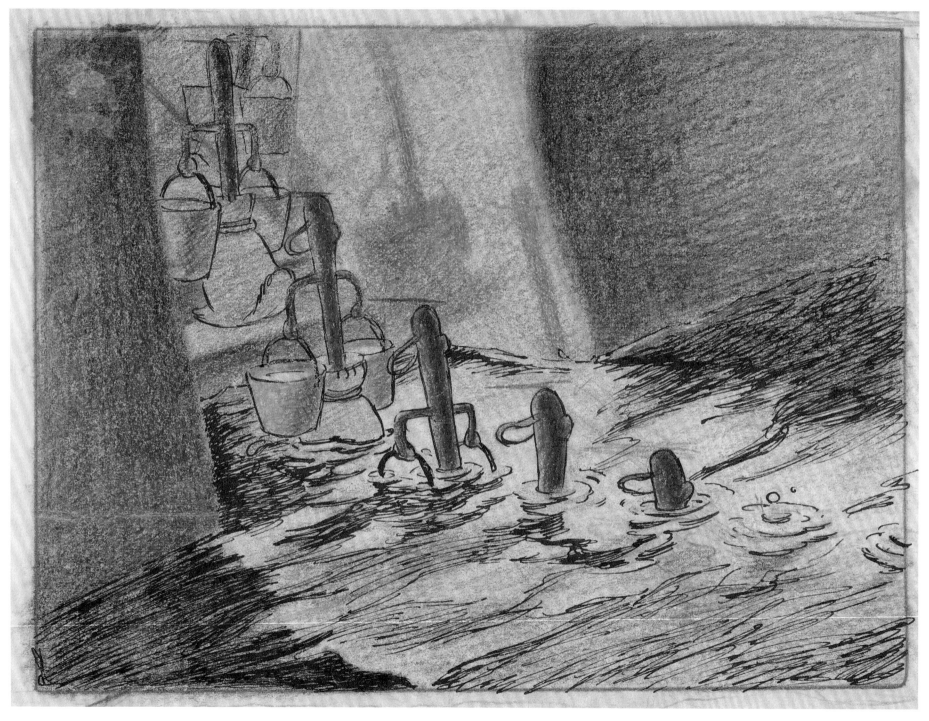

Disney Studio Artist. Story sketch. "The Sorcerer's Apprentice" segment from *Fantasia* (1940)
Colored pencil and graphite on paper | 10 x 12 inches

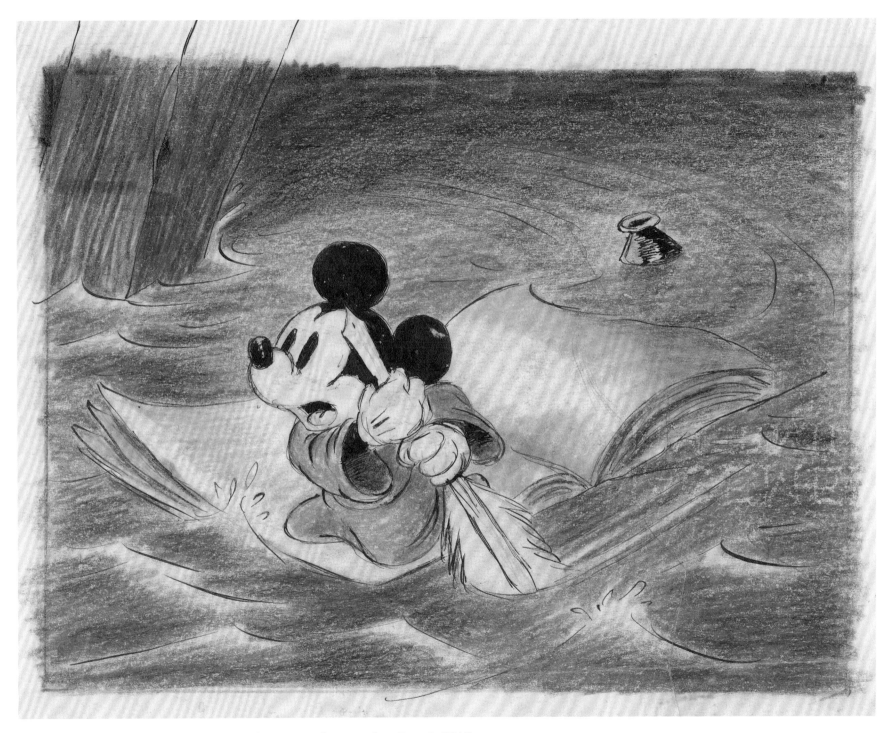

Disney Studio Artist. Story sketch. "The Sorcerer's Apprentice" segment from *Fantasia* (1940)
Colored pencil and graphite on paper | 10 x 12 inches

MICKEY IN COMICS

AS MICKEY'S STARDOM WAS RISING ON THE BIG SCREEN, Walt went to work on extending Mickey's adventures to newspapers, collaborating with Ub Iwerks on comic strips. Iwerks produced the illustrations and Walt and others wrote the stories. The first newspaper strip would debut in January 1930, following a storyline similar to the 1929 short *Plane Crazy*. For the first 18 comic strips, Mickey's animated shorts inspired the gags featured in print.

Iwerks produced the first 24 strips, then handed the responsibility over to inker Win Smith for three months. Following Smith, Floyd Gottfredson took over in May 1930 as head of the Comic Strip Department; he would continue the series for the next 45 years until his retirement. Gottfredson contributed writing from 1930 to 1932 and illustrated the strip from 1932 to 1938. During his tenure, the comic strip moved from utilizing gags from the animated shorts to developing its own continuous storylines.

In January 1933, Disney's merchandising genius Kay Kamen created *Mickey Mouse Magazine*, a small publication that would reprint newspaper comics as well as short stories, articles, and games. The magazine was a forerunner to Disney comic books and, in 1940, was succeeded by *Walt Disney's Comics and Stories*. The success of the comic book series reached its peak in September 1952, when a single issue sold more than three million copies.

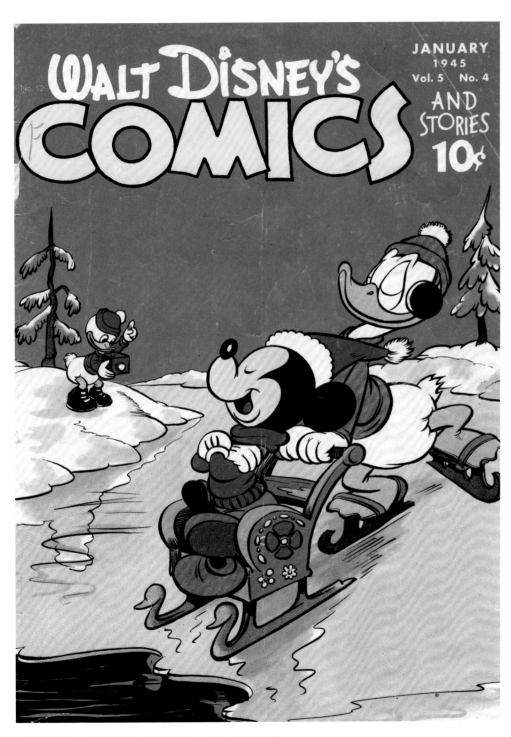

Dell Publishing. *Walt Disney's Comics and Stories*, 1945
Printed ink on paper | 10⅛ x 7½ inches

COMIC STRIP ARTISTS

ROMAN ARAMBULA

JIM ENGEL

MANUEL GONZALES

FLOYD GOTTFREDSON

RICK HOOVER

UB IWERKS

DAAN JIPPES

WIN SMITH

TED THWALLES

CARSON VAN OSTEN

BILL WRIGHT

COMIC STRIP WRITERS

DEL CONNELL

MERRILL DE MARIS

WALT DISNEY

FLOYD NORMAN

TED OSBOURNE

DICK SHAW

BILL WALSH

ROY WILLIAMS

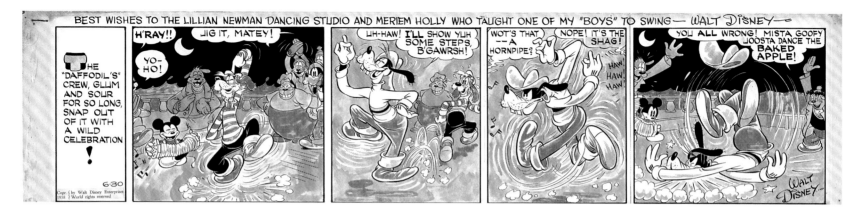

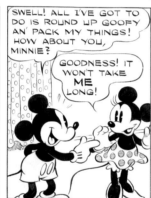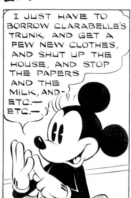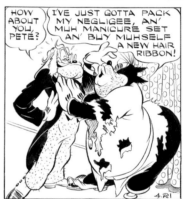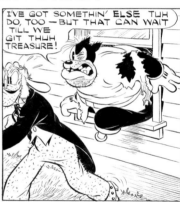

▲ Floyd Gottfredson. Daily strip original artwork, 1933
Ink and colored pencil on paper | 6¾ x 28⅞ inches

⬥ Floyd Gottfredson. Daily strip original artwork, 1937
Ink on paper | 6⅞ x 28¾ inches

⬥ Disney Studio Artist. Comic strip, 1938
Printed ink on paperboard | 6⅜ x 27⅛ inches

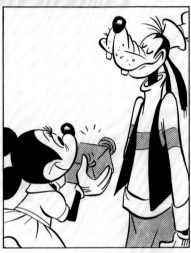

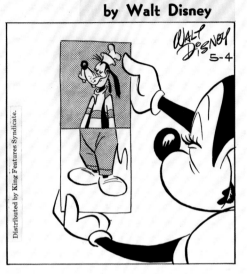

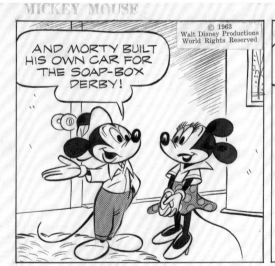

▲ Floyd Gottfredson. *Mickey Mouse* comic strip, 1963
Distributed by King Features Syndicate, Inc.
Ink and screentone on paper | 6½ x 21 inches

⬆ Floyd Gottfredson. *Mickey Mouse and his Friends* comic strip, 1960
Distributed by King Features Syndicate, Inc.
Ink and screentone on paper | 7¼ x 20 inches

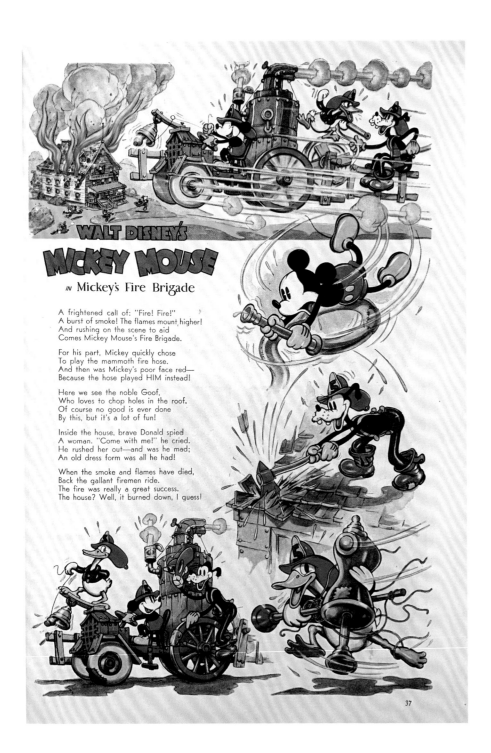

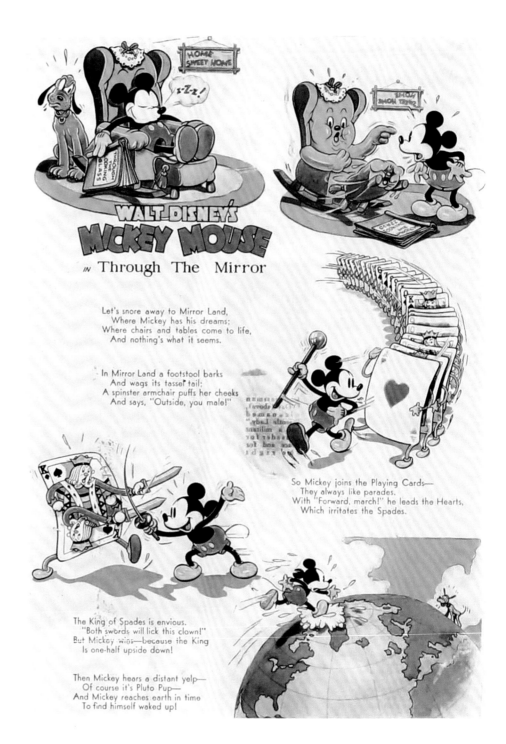

Tom Wood. Comic adapted from *Mickey's Fire Brigade* (1935). *Good Housekeeping*, 1935
Printed ink on paper | 11½ x 8½ inches

Tom Wood. Comic adapted from *Thru the Mirror* (1936), *Good Housekeeping*, 1936
Printed ink on paper | 11⅛ x 7¾ inches

Tom Wood. Original artwork for the comic adapted from *Thru the Mirror* (1936), *Good Housekeeping,* 1936
Watercolor on paper | 10¾ x 9⅝ inches

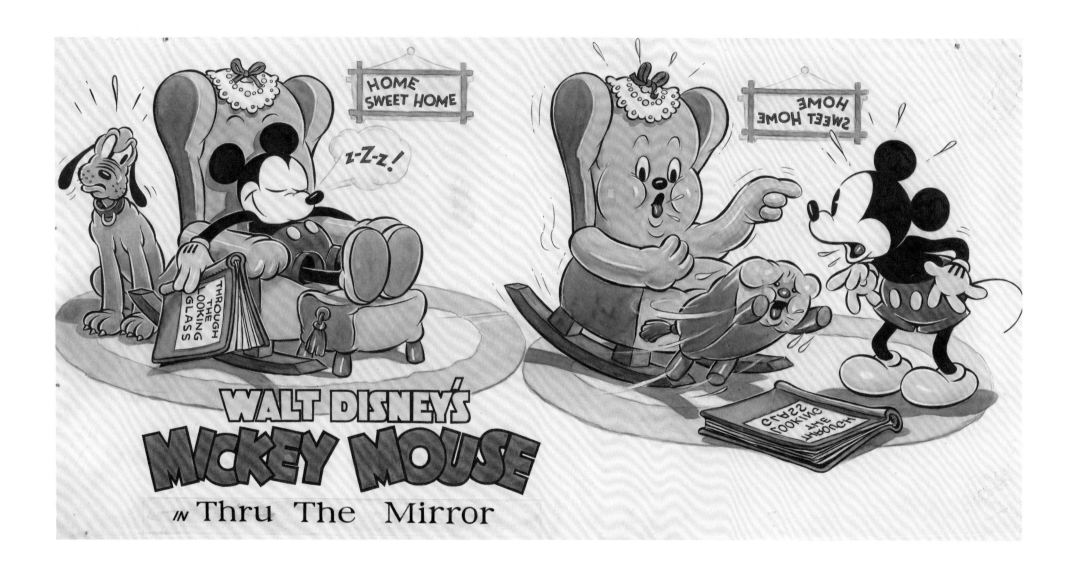

Tom Wood. Original artwork for the comic adapted from *Thru the Mirror* (1936), *Good Housekeeping*, 1936
Watercolor on paper | 9⅜ x 18¾ inches

Tom Wood. Original artwork for the comic adapted from *Thru the Mirror* (1936), *Good Housekeeping*, 1936
Watercolor on paper | 7¼ x 17½ inches

MICKEY ON TELEVISION

THE *DISNEYLAND* TELEVISION SERIES, which had debuted in October 1954, premiered its second season on ABC on September 14, 1955, and soon became the highest-rated television show of its time. On October 3, 1955, Disney introduced a new concept in children's programming with the weekday afternoon series *Mickey Mouse Club*. Walt once again created a first—entertainment designed specifically for twelve-year-old children. Walt knew that younger children would want to follow their older siblings, and teenagers' attention would draw adults' interest. The *Mickey Mouse Club* was an instant hit and made television history.

The new, young audience broke records, with more than three-quarters of the nation's television sets tuned in to the show every day. The show's young entertainers, called Mouseketeers, became overnight celebrities, and more than twenty-four thousand mouse-ear caps were sold daily. Since Mickey Mouse was featured in the beginning and at the end of each *Mickey Mouse Club* episode, his status as an American hero was guaranteed for another generation.

Disney Studio Artist.
Mickey Mouse Club
member button, c. 1955
Lithograph on metal alloy
and plastic
3½ x 3½ x ½ inches

Disney Studio Artist. Cel, c. 1955. *Mickey Mouse Club* (1955–1959)
Ink and paint on cel | 16 x 12¾ inches

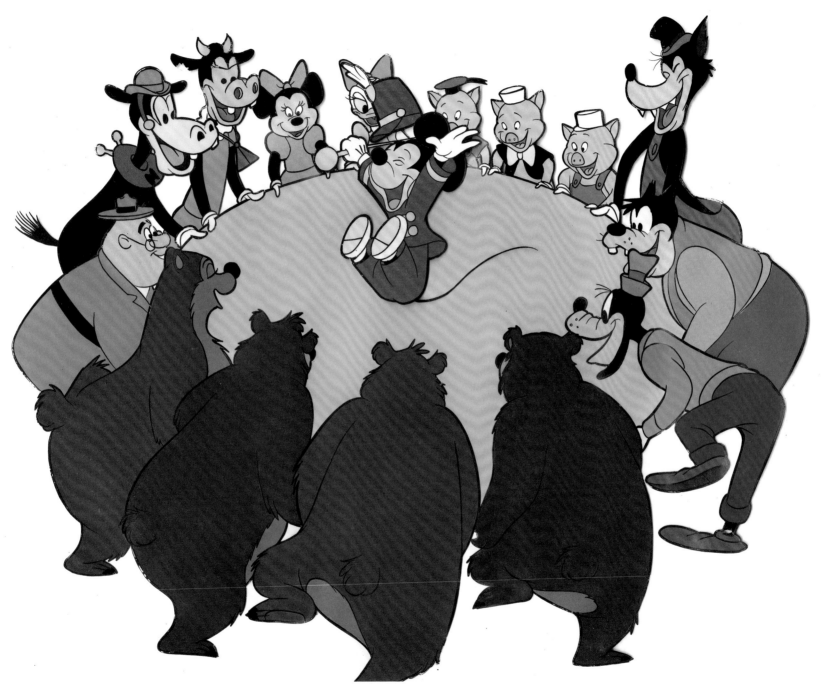

Disney Studio Artist. Cel, c. 1955. *Mickey Mouse Club* (1955–1959)
Ink and paint on cel | 12½ x 15½ inches

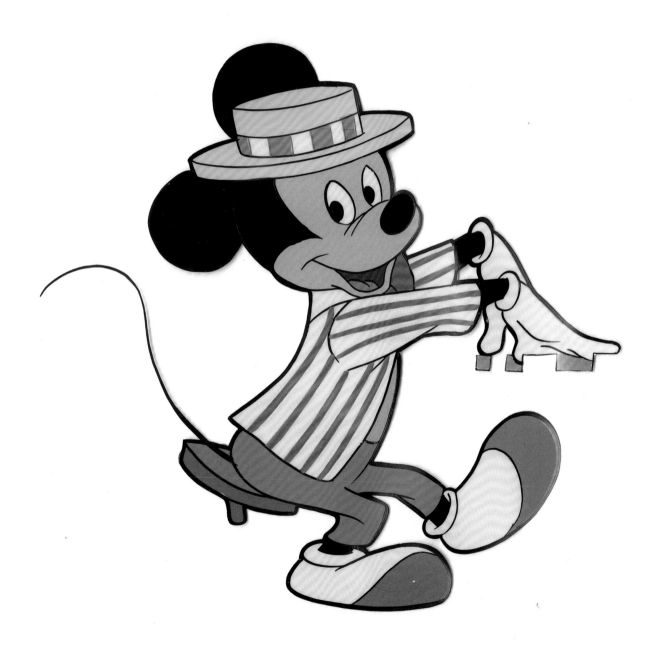

Disney Studio Artist. Cel, c. 1955
Mickey Mouse Club (1955–1959)
Ink and paint on cel | 9¼ x 11⅛ inches

Ollie Johnston. Rough animation drawings, c. 1955. *Mickey Mouse Club* (1955–1959)
Graphite and colored pencil on paper | 12½ x 15½ inches each

MICKEY MERCHANDISE

MANY PEOPLE FIRST EXPERIENCED MICKEY not in the cinema but through his ubiquitous image on watch faces, toys, games, coloring books, advertisements, and comic strips. One of the first—and most popular—items was created by Charlotte Clark in 1930. Three to four hundred dolls were produced weekly, but this sizable quantity still did not satisfy the demand. Walt and Roy were frequently asked for licensing of the Mickey character for merchandise, and, with growing interest in the doll, a contract was signed with Geo. Borgfeldt & Co. of New York, a group with a long history of dealing in novelties. By 1931, their list of licensed merchandise grew to include toys, puppets, handkerchiefs, kites, lanterns, and more. The production output was impressive, but Borgfeldt's licensees couldn't reproduce the quality and craftsmanship benchmarked by Charlotte Clark with the Mickey Mouse doll. So the Disney brothers decided on a unique solution: they released the Charlotte Clark doll pattern to the public

so that individuals could fabricate their own dolls. Profits from the sale of patterns mattered less to the Disneys than satisfying the public demand for the dolls. Produced by McCall Company of New York, Pattern No. 91—printed in English, French, and Spanish—was sold from 1932 through 1939 with great success. Charlotte Clark–designed dolls were later produced by the Knickerbocker Toy Company and Gund Manufacturing Company.

Scores of manufacturers reproduced Disney characters on most anything imaginable: tin pails with shovels for beach play, tin and porcelain cups and saucers, combs, cookie cutters, and much more. In 1932, Kay Kamen, considered one of the country's leading promotion men, approached Walt about working with Disney character merchandise. After netting an exclusive contract with the brothers, Kamen represented them in all matters pertaining to contracts with authorized licensees of Disney product and assisted them by

presenting new ideas for the development of Mickey Mouse merchandise.

Within the first year, Kamen became completely familiar with the business and began issuing licensing to manufacturers for product not covered in previous contracts. Within six months, he was able to report multi-million-dollar merchandise sales; in 1933, almost a million Ingersoll watches and clocks were sold. Another one of the most spectacular merchandising success stories was an association with the Lionel Corporation in 1934. Within four months, the company pulled itself out of receivership by selling more than a quarter million tin wind-up hand cars, which ran on a 27-inch circular track and featured Mickey and Minnie mouse at the handles.

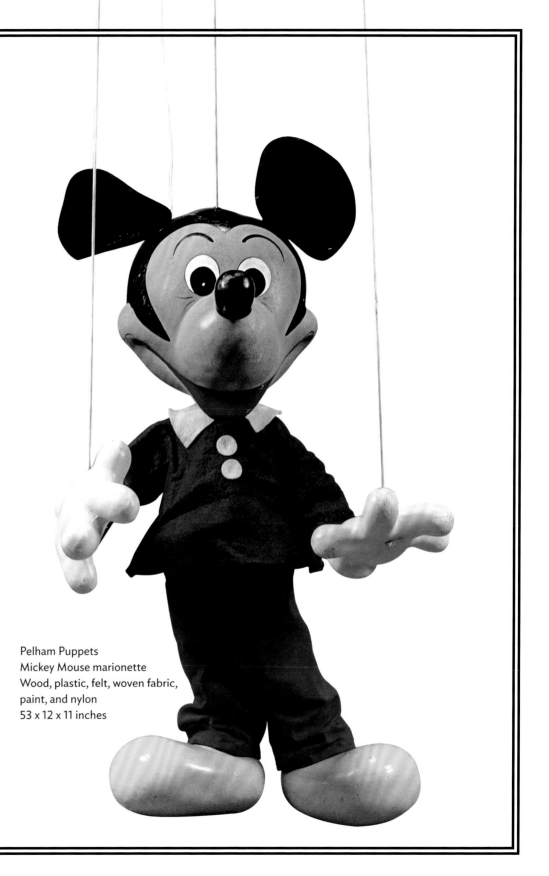

Pelham Puppets
Mickey Mouse marionette
Wood, plastic, felt, woven fabric,
paint, and nylon
53 x 12 x 11 inches

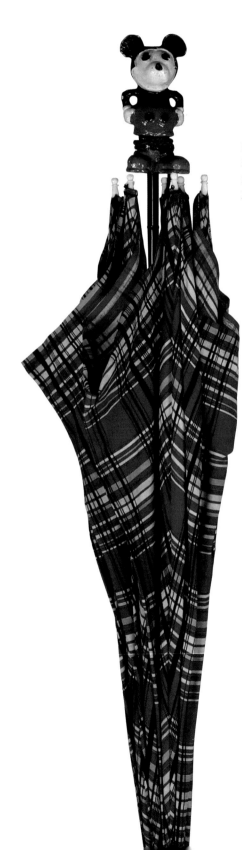

Louis Weiss.
Mickey Mouse umbrella, c. 1935
Metal alloy, plastic, fabric, and wood
20 x 6 x 6 inches

Mattel Inc.
Mouseketeers Mousegetar Jr., c. 1955
Plastic and printed ink on paper
14 x 4¾ x 2 inches

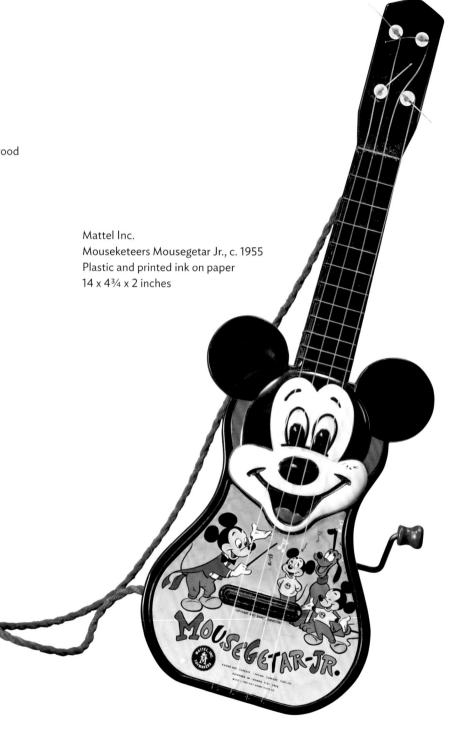

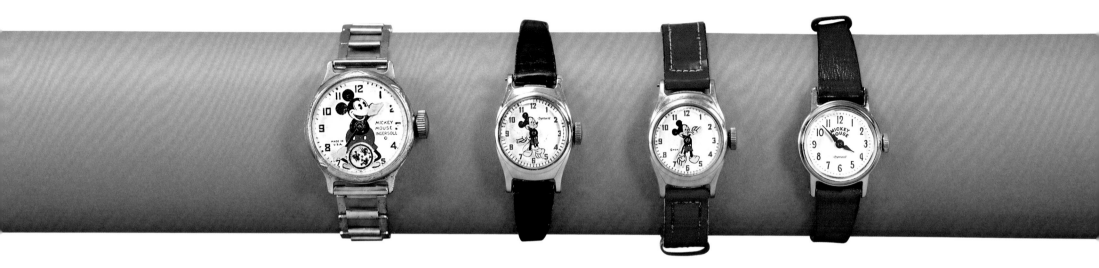

Timex and Ingersoll Watch Company
Mickey Mouse watches and pocket watch
Metal alloy, printed ink, glass, enamel, vinyl,
and leather. Various production dates.

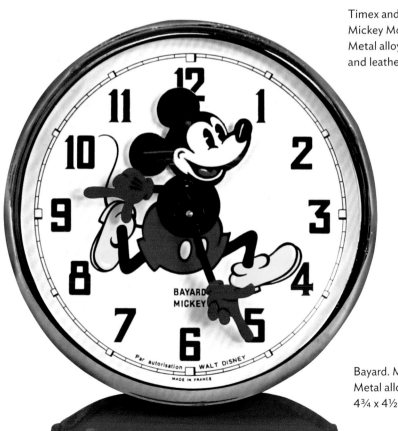

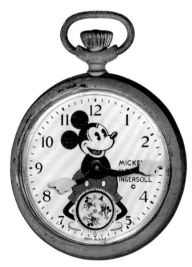

Bayard. Mickey Mouse clock, 1947
Metal alloy, enamel, and printed ink
4¾ x 4½ x 2⅛ inches

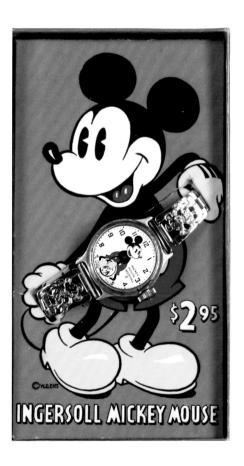

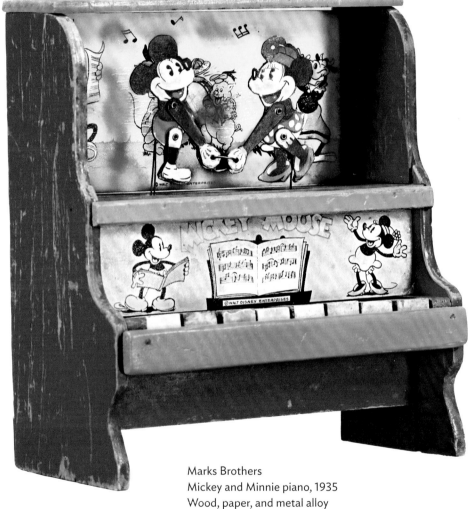

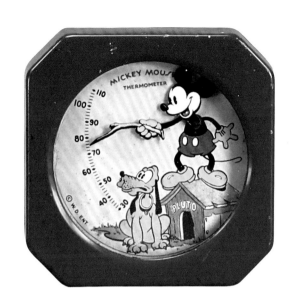

Character Art Company
Mickey Mouse thermometer, 1930s
Metal alloy, printed ink on paper, and paint
3¼ x 3¼ x 1 inches

Marks Brothers
Mickey and Minnie piano, 1935
Wood, paper, and metal alloy
10¼ x 9¼ x 5¼ inches

Cub Pack 38. Mickey Mouse
bookend, gifted to Walt from a
Boy Scout troop, c. 1935
Copper paint on wood
8½ x 6 x 4½ inches

Lenticular Mickey Mouse ID tag from the Art Corner
at Disneyland, 1955–1966
Plastic, paper, and metal alloy | 3¼ x 1⅝ inches

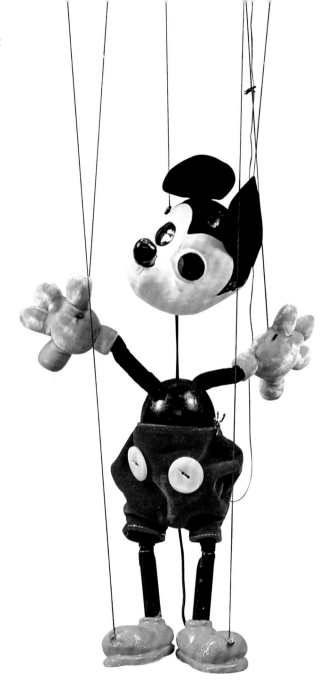

Hestwood Studios. Mickey Mouse marionette, 1930s
Wood, paint, string, fabric, and metal alloy
14 x 7½ x 4 inches

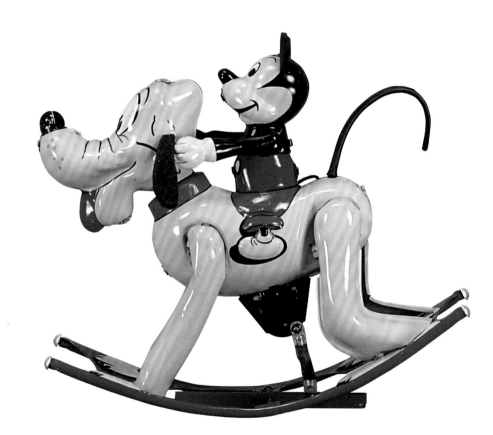

Linemar Toys. Mickey Mouse and Pluto wind-up toy, 1940s
Lithograph on metal alloy, rubber, and elastic cord
6 x 7 x 4½ inches

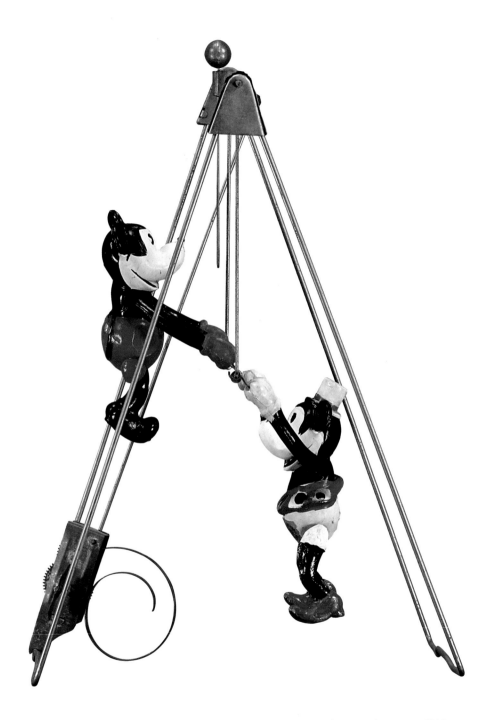

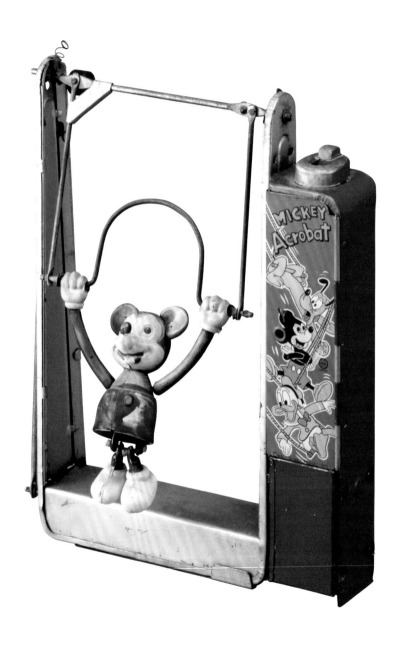

Geo. Borgfeldt & Co. Mickey Mouse and Minnie Mouse wind-up acrobat toy, c. 1930
Metal alloy and celluloid | 13 x 9 x 6½ inches

Linemar Toys. Mickey Mouse acrobat toy, 1950s
Lithograph on metal alloy and celluloid | 9½ x 7 x 3 inches

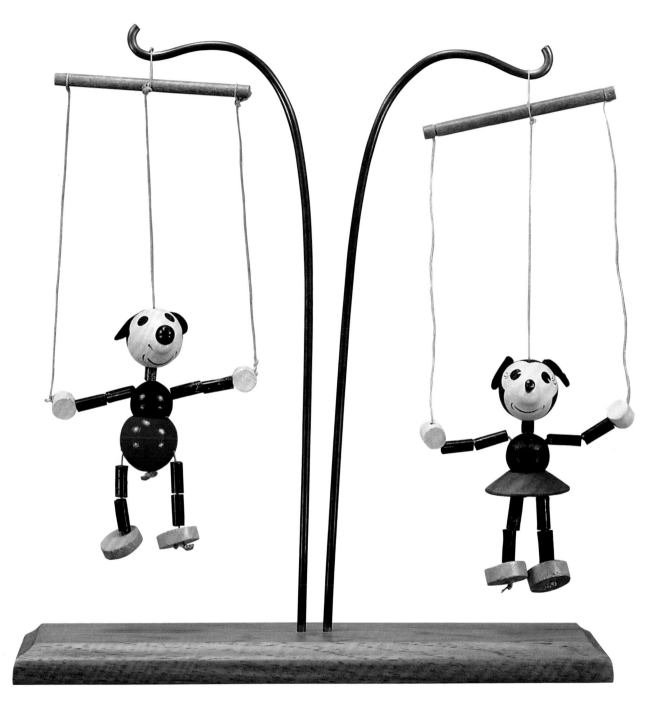

Pelham Puppets. "Minipup" Mickey Mouse marionette, 1930s
Wood, string, paint, and fabric | 10 x 4¼ x 2½ inches

Pelham Puppets. "Minipup" Minnie Mouse marionette, 1930s
Wood, string, paint, and fabric | 10¼ x 4½ x 2½ inches

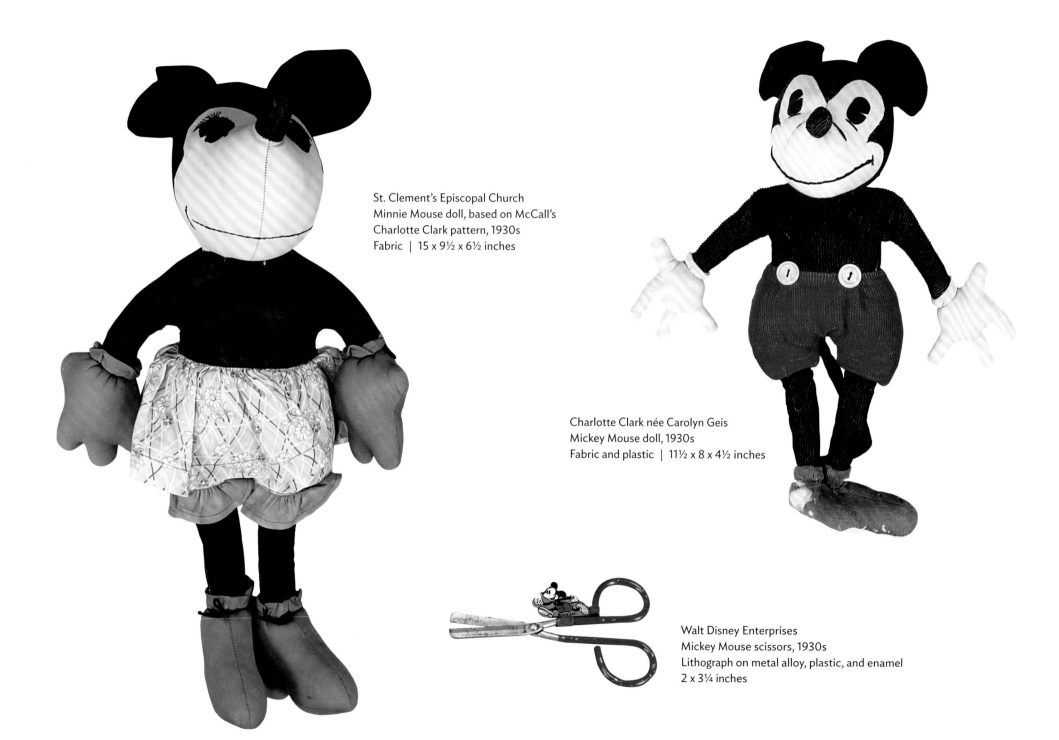

St. Clement's Episcopal Church
Minnie Mouse doll, based on McCall's
Charlotte Clark pattern, 1930s
Fabric | 15 x 9½ x 6½ inches

Charlotte Clark née Carolyn Geis
Mickey Mouse doll, 1930s
Fabric and plastic | 11½ x 8 x 4½ inches

Walt Disney Enterprises
Mickey Mouse scissors, 1930s
Lithograph on metal alloy, plastic, and enamel
2 x 3¼ inches

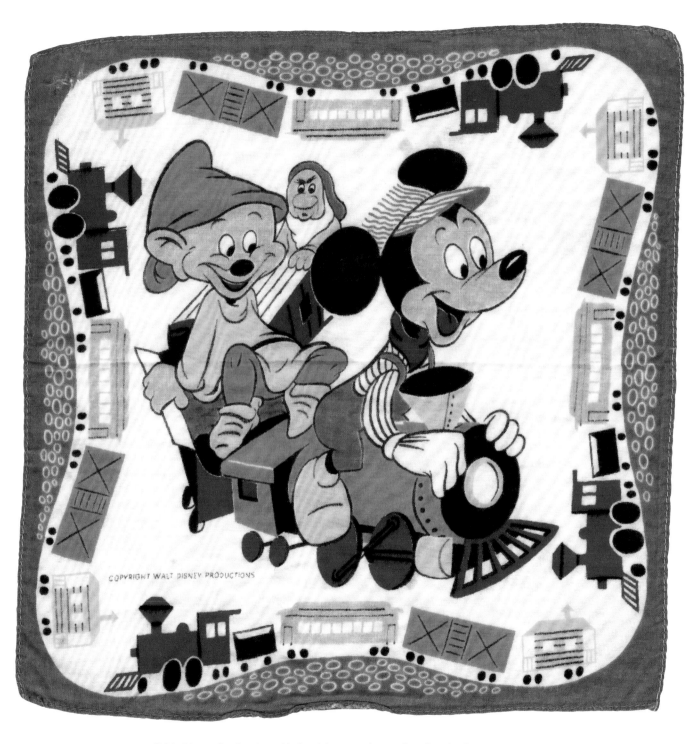

Walt Disney Productions. Mickey Mouse and trains handkerchief, 1960s
Printed ink on cotton fabric | 8¼ x 8¼ inches

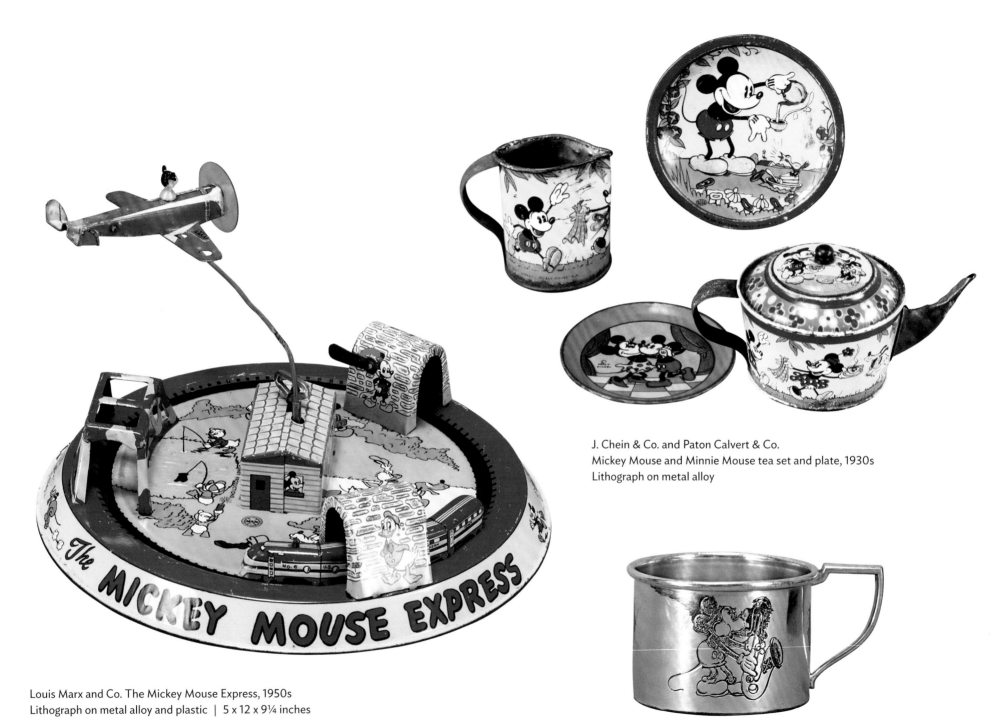

J. Chein & Co. and Paton Calvert & Co.
Mickey Mouse and Minnie Mouse tea set and plate, 1930s
Lithograph on metal alloy

Louis Marx and Co. The Mickey Mouse Express, 1950s
Lithograph on metal alloy and plastic | 5 x 12 x 9¼ inches

International Silver Company. Mickey Mouse cup, 1934
Silver plated metal alloy | 2 x 3½ x 2½ inches

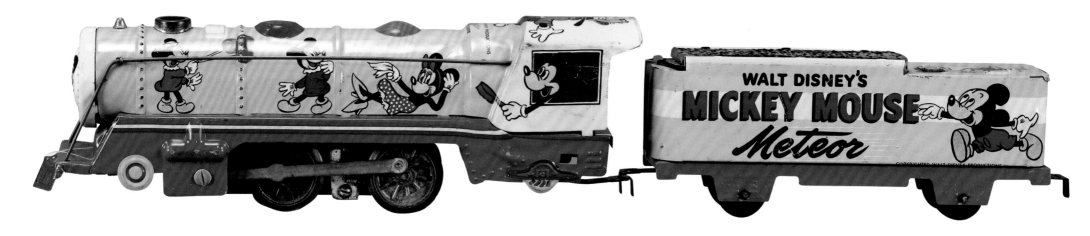

Linemar Toys. Walt Disney's Mickey Mouse Meteor electric train engine and coal hopper, 1950s
Lithograph on metal alloy | 3½ x 19 x 2½ inches

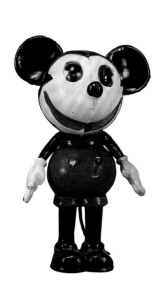

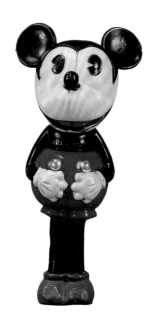

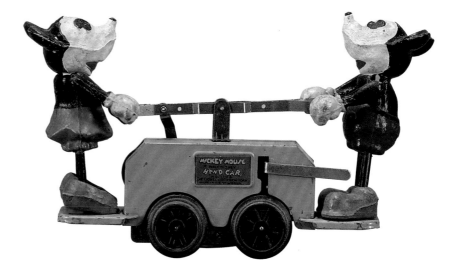

Geo. Borgfeldt & Co., 1930s
Mickey Mouse figurine
Celluloid | 5¼ x 3 x 2½ inches

Geo. Borgfeldt & Co., 1930s
Mickey Mouse figurine
Celluloid | 6 x 2¾ x 2⅝ inches

Lionel Corporation. Mickey Mouse hand car, c. 1934
Metal alloy, composite material, and paint | 5½ x 9¼ x 3 inches

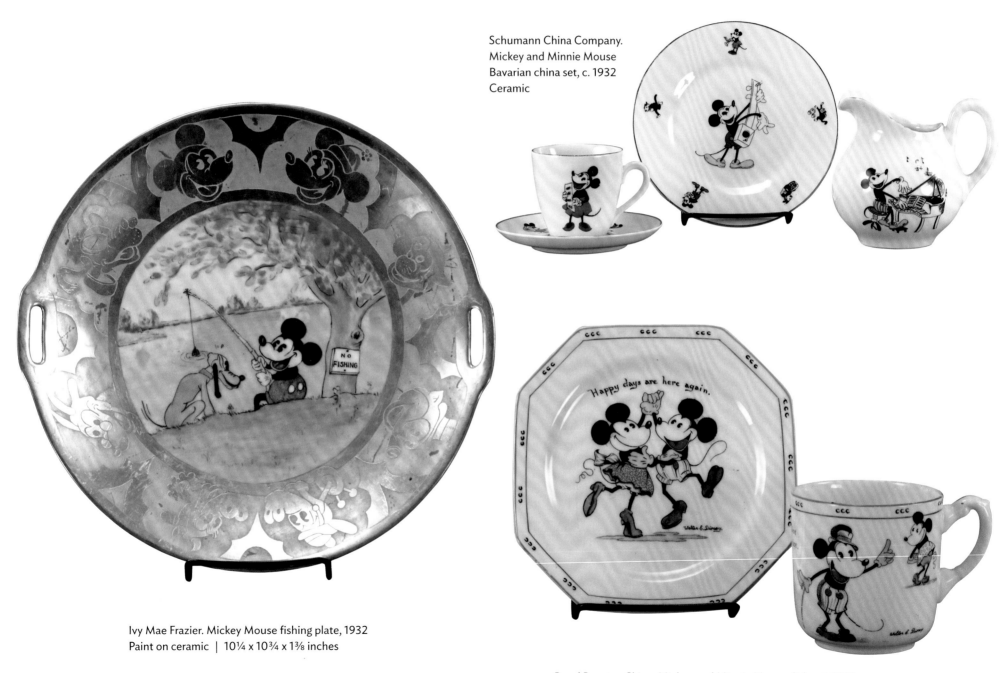

Schumann China Company.
Mickey and Minnie Mouse
Bavarian china set, c. 1932
Ceramic

Ivy Mae Frazier. Mickey Mouse fishing plate, 1932
Paint on ceramic | 10¼ x 10¾ x 1⅜ inches

Royal Paragon China. Mickey and Minnie Mouse dish set, 1930s
Ceramic

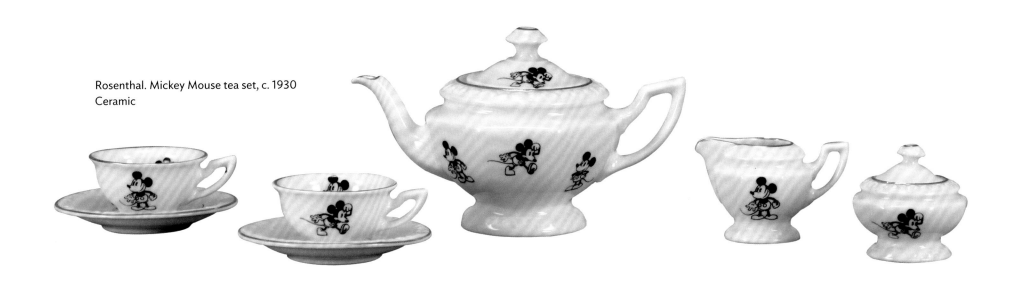

Rosenthal. Mickey Mouse tea set, c. 1930
Ceramic

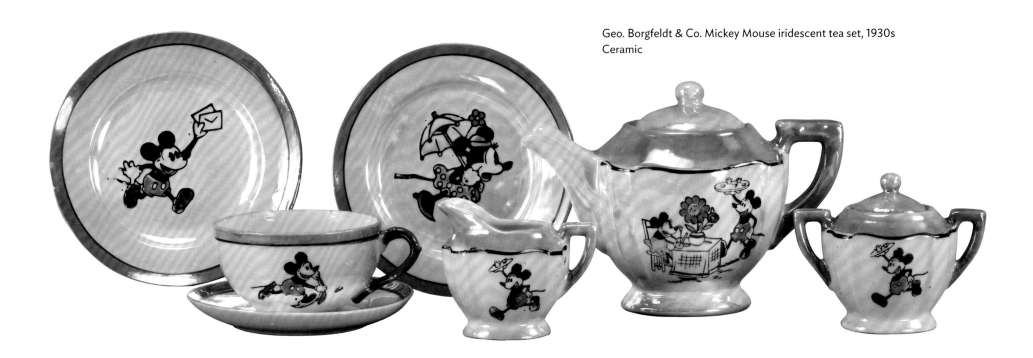

Geo. Borgfeldt & Co. Mickey Mouse iridescent tea set, 1930s
Ceramic

◄ Goebel. Mickey Mouse hunter figurine, 1950s
Paint on ceramic | 4¾ x 3½ x 2½ inches

► Kohner Brothers Inc. Mickey Mouse toy, 1960s
Plastic | 5¼ x 3⅛ x 3⅛ inches

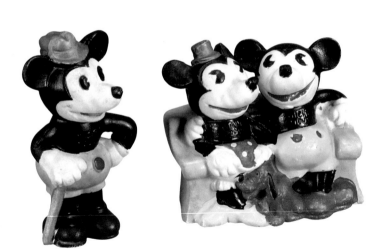

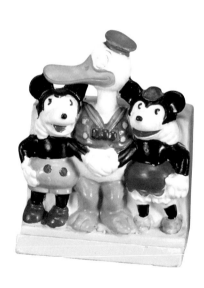

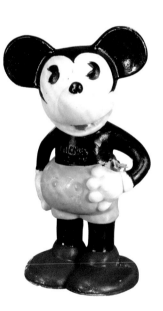

Geo. Borgfeldt & Co. Mickey Mouse bisque figurines and
Donald Duck, Mickey Mouse, and Minnie Mouse toothbrush holder, 1930s
Paint on ceramic

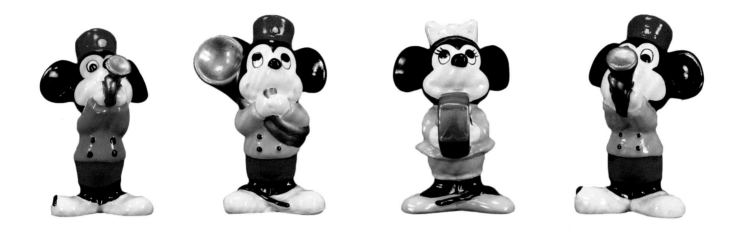

UOGC. Mickey Mouse and Minnie Mouse figurines, c. 1960
Paint on ceramic

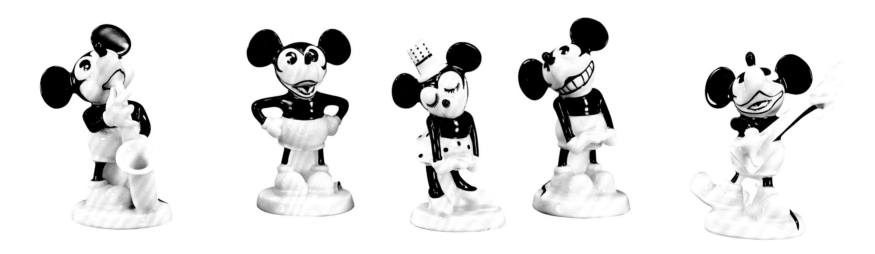

Rosenthal. Mickey Mouse and Minnie Mouse figurines, c. 1930
Ceramic

"[Mickey] was the first cartoon character to express personality and to be constantly kept in character. . . . It gave his character new dimension. It rounded him into complete lifelikeness."

—Walt

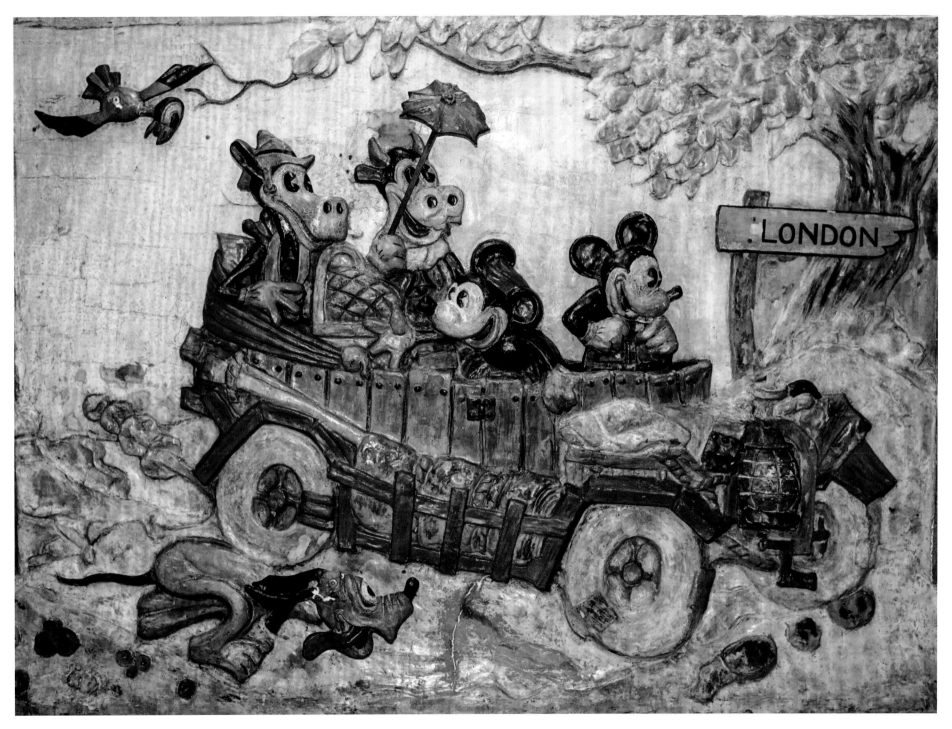

Kamen Limited. Auto Ride store display, c. 1935
Papier-mâché, paint, and wood | 63 x 88¼ x 12½ inches

MICKEY INTERNATIONAL

BY 1931, the theater-based Mickey Mouse Club program had an estimated one million members, and Mickey was known all over the world. Movie star Douglas Fairbanks, Sr.—who most famously portrayed swashbuckling heroes such as the Thief of Bagdad, Zorro, and Robin Hood—was said to ingratiate himself with indigenous Polynesian peoples by showing them Mickey Mouse cartoons. His film star wife, Mary Pickford, declared Mickey to be her favorite star. In London, Madame Tussauds museum enshrined Mickey in wax. Even the First Lady of the United States Eleanor Roosevelt wrote to Walt Disney from the White House, saying, "My husband is one of the devotees of Mickey Mouse. . . . Please believe that all of us are most grateful to you for many delightful evenings."

In 1930s Europe, Mickey Mouse also became the main attraction of a number of widely read comic publications, including *Topolino* in Italy, *Le Journal de Mickey* in France, *Don Miki* in Spain, and *Miky Maous* in Greece. A dedicated series, *Biblioteca de adventuras Mickey*, was soon published in Barcelona, Spain, by Editorial Alas; titles included *Mickey y su jazz/Mickey Bambero* (1934), *Mickey Calzador/Mickey Taxista* (1935), and *Mickey y los Indios/Mickey Caballista* (1935).

By 1958, Mickey Mouse had been introduced to the Middle East through another popular comic book entitled *Sameer*, prompting a dedicated Mickey comic to be published in Egypt shortly thereafter. Licensed by Disney, Mickey comics continue to be wildly successful throughout Egypt, having been published since 1959 by Dar Al-Hilal.

In later years, Mickey was the main character for the Italian series *MM-Mickey Mouse Mystery Magazine* from 1999 to 2001. In 2006, he appeared again in the Italian fantasy comic saga *Wizards of Mickey*. Books and comics about Mickey Mouse and his friends are currently published in more than 40 different languages.

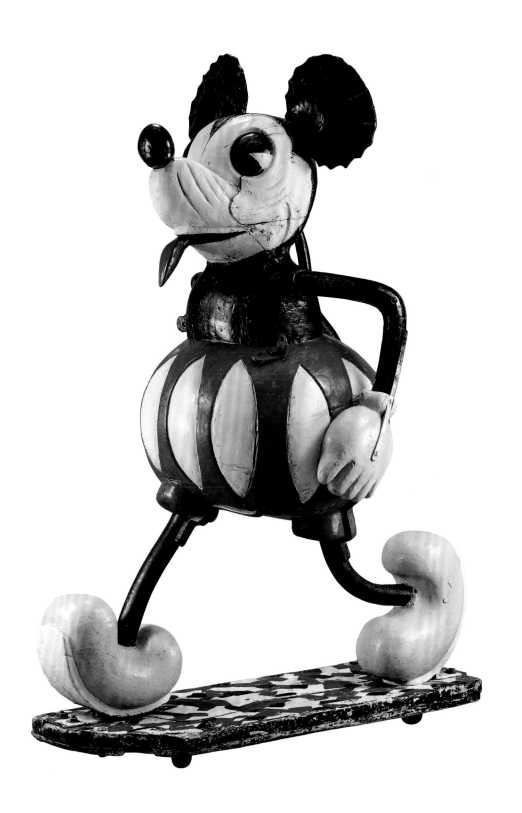

Henri De Vos Company.
Mickey Mouse French
carousel figure, c. 1930
Wood, paint, and iron
49¼ x 20½ x 36 inches

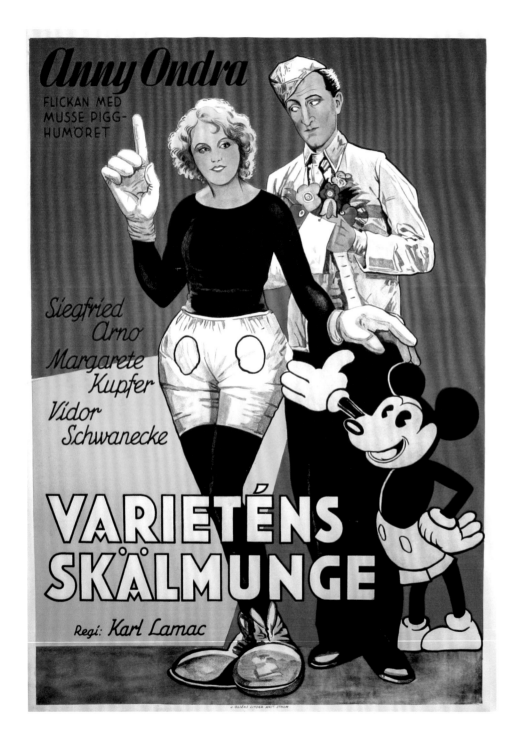

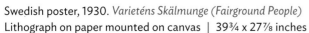

Swedish poster, 1930. *Varieténs Skälmunge (Fairground People)*
Lithograph on paper mounted on canvas | 39¾ x 27⅞ inches

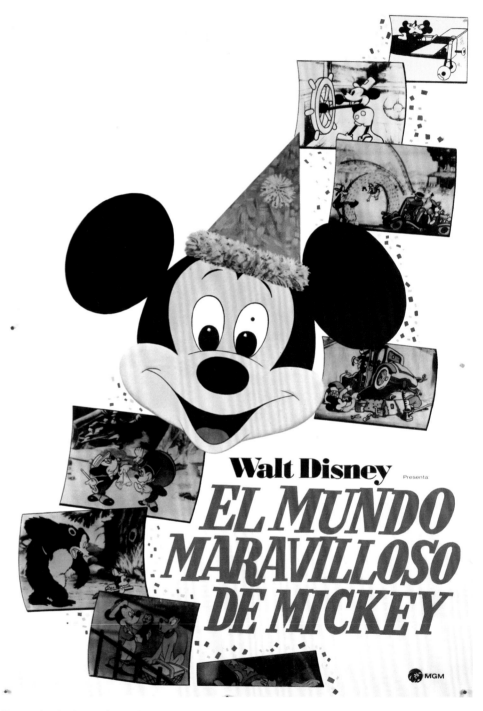

Disney Studio Artist. Spanish poster, 1971
El Mundo Maravilloso de Mickey (The Wonderful World of Mickey)
Printed ink on paper | 43½ x 29½ inches

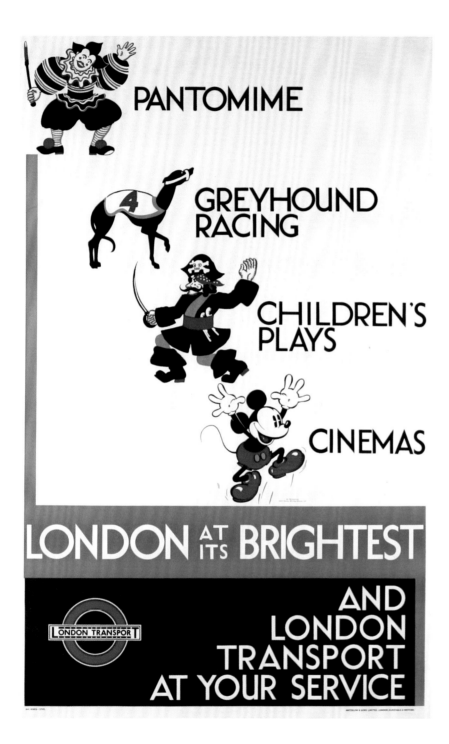

Disney Studio Artist. London Underground transit poster, 1934
Printed ink on paper | 40 x 25¼ inches

Disney Studio Artist. Argentinean poster, c. 1947
The "Bongo" segment from *Fun and Fancy Free* (1947)
Printed ink on paper on canvas | 48⅜ x 29½ inches

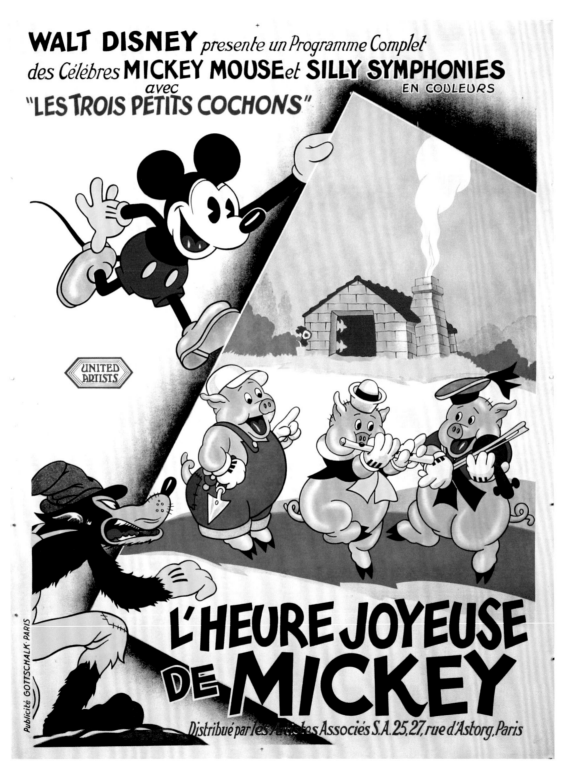

French poster, c. 1934
L'Heure Joyeuse de Mickey
(The Joyous Hour of Mickey)
Three Little Pigs (1933)
Printed ink on paper
63 x 47⅝ inches

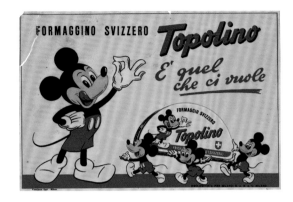

◄ Disney Studio Artist. Italian Mickey Mouse Topolino cheese label
Printed ink on thin glossy paper | 7¾ x 11⅜ inches

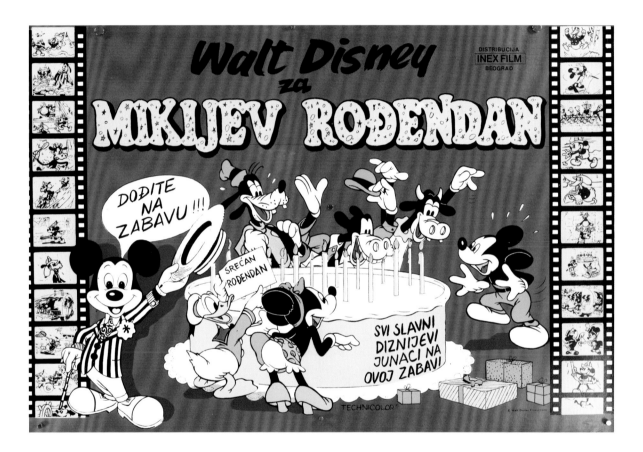

▲ Disney Studio Artist. Yugoslavian poster, 1953. *Mikijev Rodendan (Mickey's Birthday Party)*
Printed ink on paper | 18⅝ x 27½ inches

◄ Disney Studio Artist. Australian Mickey Mouse stock poster, 1930s
Printed ink on paper on canvas | 30¼ x 13¼ inches

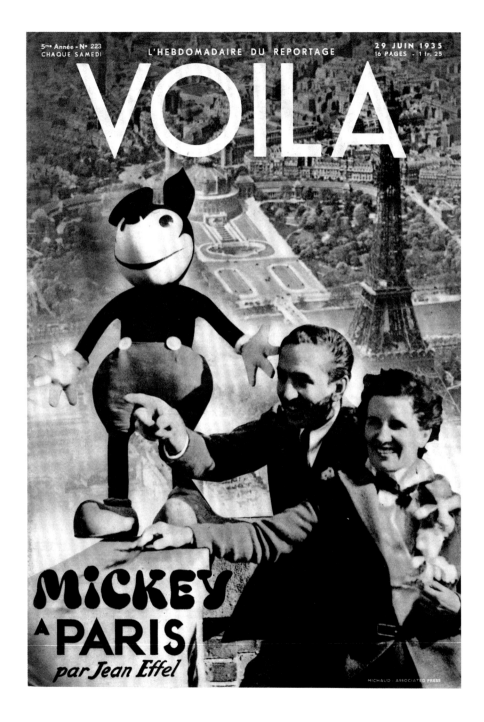

French *Voila* magazine, "Mickey a Paris," 1935
Printed ink on paper | 17 x 11⅞ inches

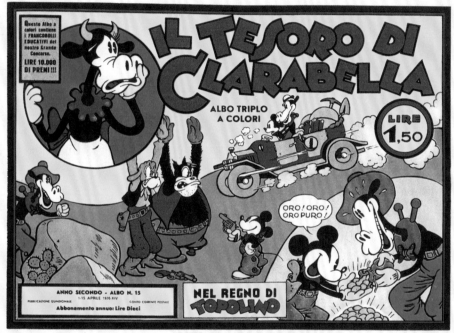

Disney Studio Artist. Italian book cover, 1980s
Topolino e il tesoro di Clarabella (Mickey Mouse and the Treasure of Clarabelle)
Original title: *Race for Riches*
Softcover cardboard and printed ink on paper | 9½ x 12⅞ inches

Disney Studio Artist. Italian poster, 1932. *Topolino Story (A Mickey Mouse Story)*
Printed ink on paper | 18¾ x 26¼ inches

Disney Studio Artist. Italian poster, c. 1952
Le Peripezie di Pippo, Pluto, e Paperino (Trick or Treat)
Printed ink on paper | 19 x 26¾ inches

MICKEY IN FINE ART

MICKEY MOUSE DEBUTED IN A MAJOR WORK OF ART— apart from the art of The Walt Disney Studios—in December 1932, when he appeared in *The Arts of Life in America*, a cycle of eight mural paintings by Thomas Hart Benton. Since then, artists such as Andy Warhol, Roy Lichtenstein, and Keith Haring have endeavored to depict Mickey—that wholesome symbol of happiness and nostalgia, inextricably linked to the American spirit of ingenuity and success—in their own unique ways. For the pop artists of the 1960s in particular, Mickey was a personification of popular culture: not only was he reproduced constantly on merchandise and elsewhere, his simplistic, bright design echoed that of advertisements and invoked the very American nature of animation and cartoon art as a whole.

In 2012, artist Damien Hirst created his own interpretation of Mickey: several spots on a canvas, in red, yellow, off-white, and black paint. Hirst noted that the character "is still instantly recognizable—Mickey Mouse is such a universal and powerful icon." Even boiled down to his most basic elements—the circles that Iwerks first drew, the simple colors that later Disney artists added—Mickey is an indelible image whose ubiquity is still unsurpassed in popular culture today. In 2005, *Variety* recognized that fact by naming him one of the top 100 media icons of the 20th century.

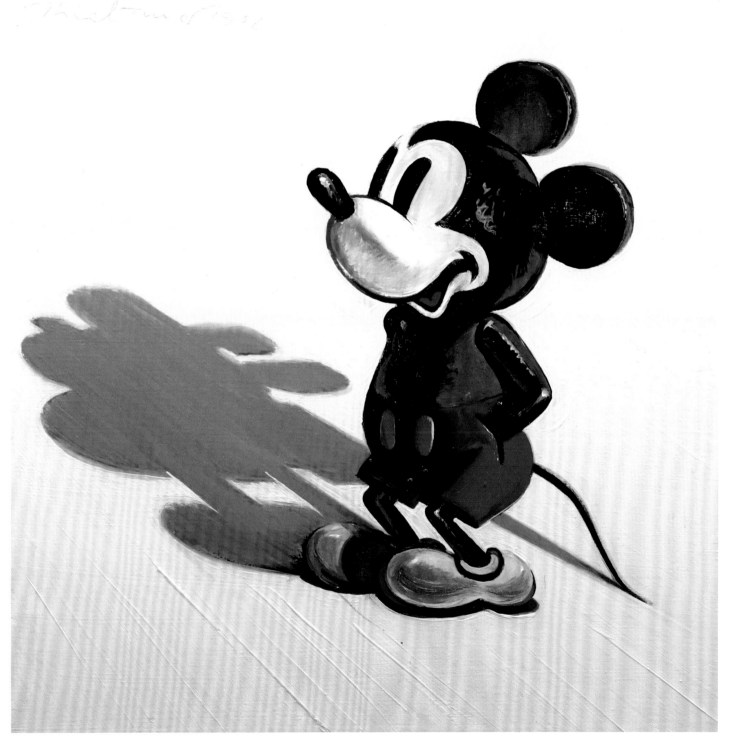

Wayne Thiebaud. *Toy Mickey* (1988)
Acrylic on board | 12¼ x 12 inches

Wayne Thiebaud is an American painter who
is most often associated with the pop art
movement of the 1960s, perhaps due to his
iconic still lifes of colorful, edible treats, such as
cakes and ice cream cones, and commonplace
objects. While he was in high school, he
became interested in stage design and lighting,
made posters for the lobby displays at a local
theater. Today, Thiebaud's work is housed in
the collections of the San Francisco Museum of
Modern Art, the Los Angeles County Museum,
and the Whitney Museum, and, in 1994, he was
awarded the National Medal of Arts.

When Walt Disney passed on December 15, 1966, editorial cartoons around the world honored his life and legacy with illustrations that featured an array of his iconic characters, including Donald Duck, Pluto, Snow White, and more. These characters were shown grieving for Walt, sitting with him, or fondly eulogizing him. Perhaps unsurprising, the character depicted most often was Walt's iconic Mickey Mouse, who acted, as he had before, as a sort of stand-in or parallel figure to Walt, thus communicating the void left by Walt's passing most effectively.

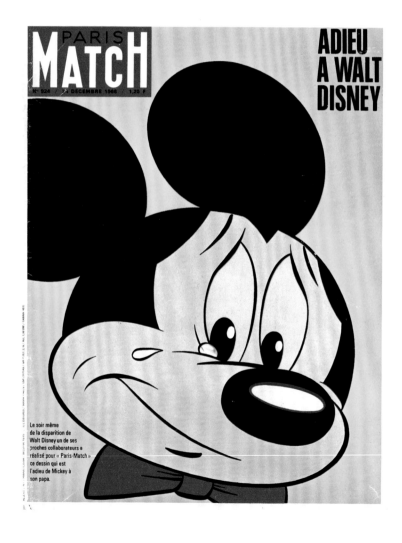

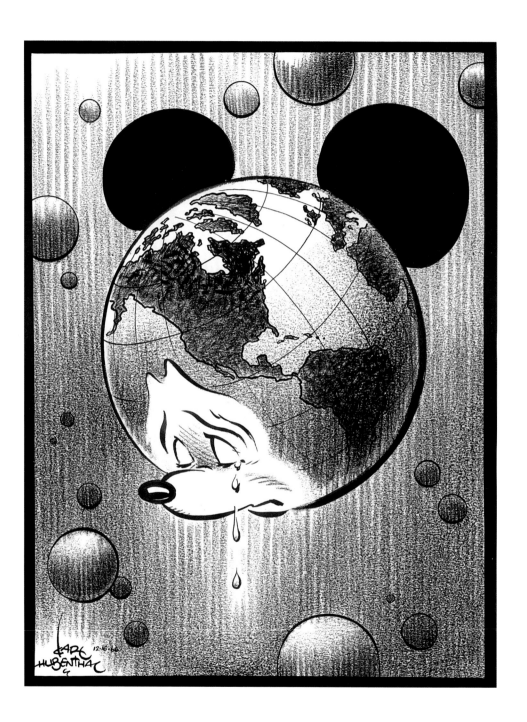

Paris Match magazine, "Adieu a Walt Disney," 1966
Printed ink on paper | 13¼ x 10½ inches

Karl Hubenthal. Drawing. *Los Angeles Herald Examiner*, 1966
Black wax pencil on paper | 16½ x 12½ inches

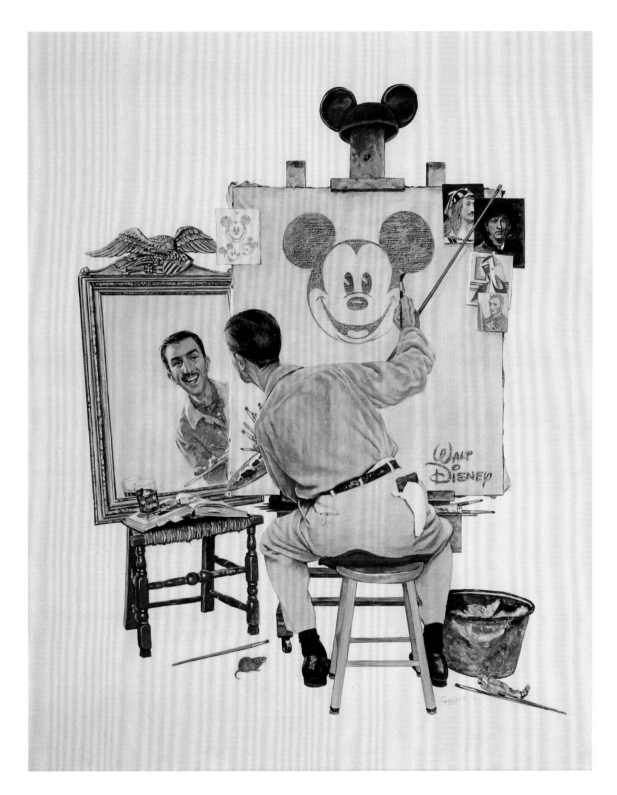

"Whenever I see Mickey Mouse
I have to cry, because he reminds
me so much of Walt."
—Lillian Disney

Charles Boyer. *Triple Self-Portrait* (1978)
Oil paint on canvas | 33¾ x 27¾ inches

In 1960, Charles Boyer accepted a "temporary" job at
Disneyland, but he ended up staying on for 39 years. He
holds the distinction of becoming Disneyland Park's first
full-time artist and ended up creating dozens of lithographs
as well as art pieces for brochures, posters, oil paintings
of retirees, and other materials, until he himself retired
in 1999. One of his most beloved paintings is a parody
of Norman Rockwell's *Triple Self-Portrait*, which features
Walt Disney painting Mickey Mouse. In 2005, Boyer was
honored as a Disney Legend.

Matsumi Kanemitsu. *Mickey Mouse Series* (1970)
Lithograph on paper on canvas | 8 x 10 inches each

Matsumi Kanemitsu was a Japanese-American abstract
expressionist painter, also known for his proficiency in Japanese-
style sumi and lithography. Though he was born in Ogden, Utah,
his family moved to a suburb of Hiroshima, Japan, when he was
three years old. Despite enlisting in the United States Army
in 1941, Kanemitsu was arrested and placed in an internment
camp following the attack on Pearl Harbor. While interned,
he began drawing and, upon his release, pursued a formal art
education, which led to his association with other notable abstract
expressionists such as Jackson Pollock and Willem de Kooning.
Later on, Kanemitsu became a faculty member at both Chouinard
Art Institute and Otis College of Art and Design.

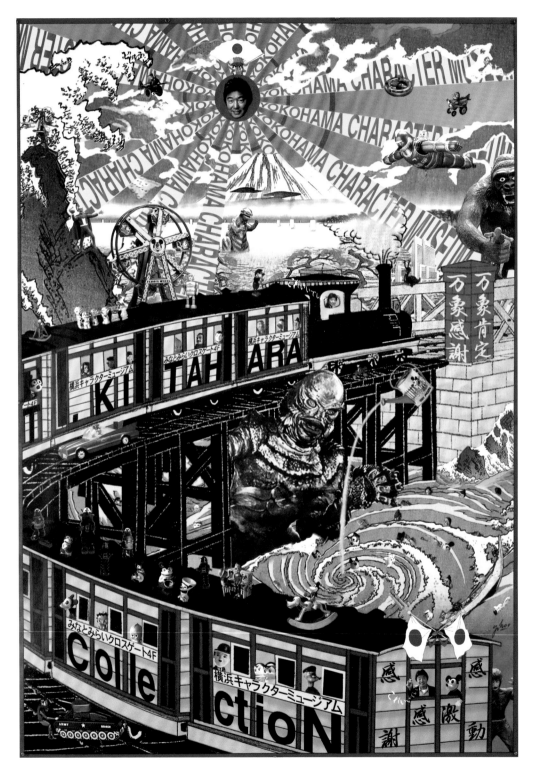

opposite left ▸ Damien Hirst. *Mickey for Bob* (2014)
Household gloss on canvas
72 x 42½ inches

opposite right ▸ Damien Hirst. *Gold Mickey* (2014)
Household gloss and gold leaf on canvas
72⅘ x 53¹⁄₁₀ inches

Since emerging onto the international art scene in the
late 1980s, Damien Hirst has created installations,
sculptures, paintings, and drawings that examine the
complex relationships between art and beauty, religion
and science, and life and death. From serialized paintings
of multicolored spots to animal specimens preserved in
tanks of formaldehyde, his work challenges contemporary
belief systems, tracing the uncertainties that lie at the
heart of human experience. At the invitation of Disney,
Hirst remade Mickey Mouse with different colored
backgrounds as part of his iconic series of spot paintings.

Tadanori Yokoo. Poster for the Yokohama
Character Museum, 2000
Printed ink on paper | 40½ x 28⅝ inches

Tadanori Yokoo is a Japanese graphic designer, illustrator,
printmaker, and painter. He embraced a pop art aesthetic
in Japan during the 1960s and went on to design book
covers, posters, and corporate illustrations. Yokoo's work
often takes inspiration from traditional Japanese pictorials
and prints, along with Western popular culture motifs and
imagery, though since the 1980s he has painted in a mainly
abstract figurative style.

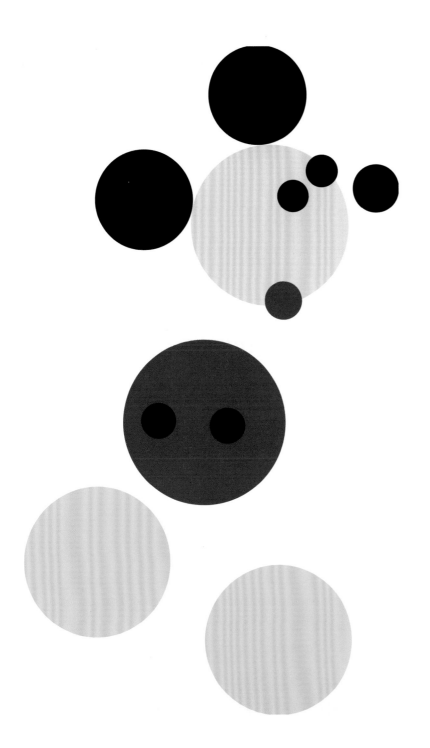

Tennessee Loveless is an artist currently based in Chicago, Illinois. Being colorblind, Loveless understands hues in a conceptual way, often making choices based on the fundamentals of color theory, word association, and color psychology, instead of considering the color itself. From painting drag queens and capturing underground drag culture on canvas in early 2000s San Francisco to creating art for an official selection at the Cannes Film Festival, Loveless has had an extensive and multifaceted career. He has created officially licensed art for both The Walt Disney Company and Warner Bros. Perhaps most notable, his 10x10x10 series, which is based on 100 silhouettes of Mickey Mouse, explores the history of the iconic character and brings added global, societal, and personal context to the imagery.

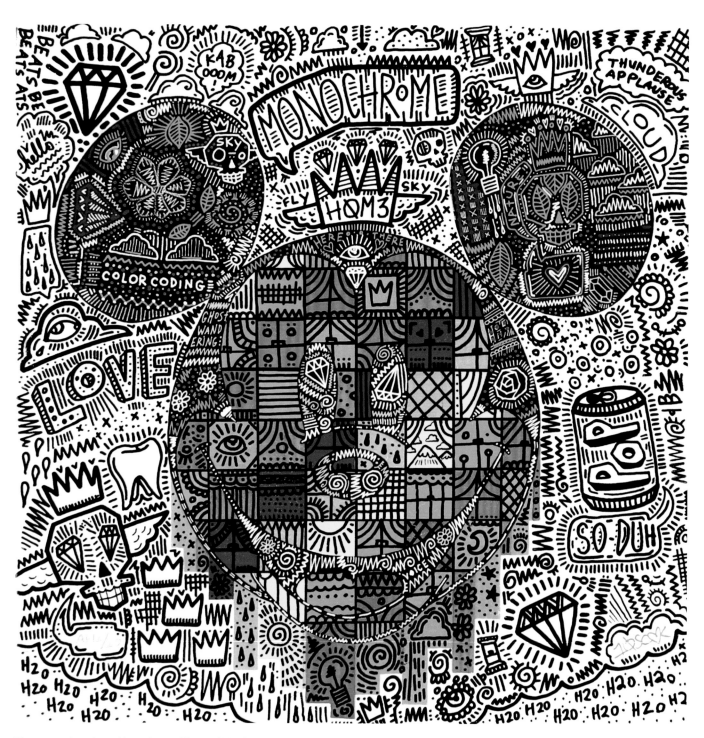

Tennessee Loveless. *Monochrome Throne* (2013)
Ink overlay on giclée | 14 x 14 inches

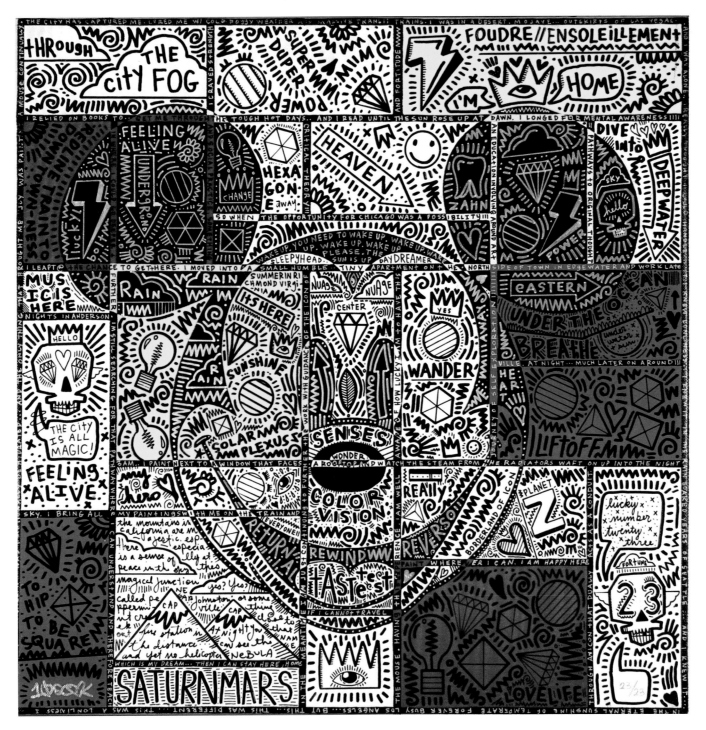

Tennessee Loveless. *Mickey Modified Mondrian* (2016)
Ink overlay on giclée | 18⅛ x 18⅛ inches

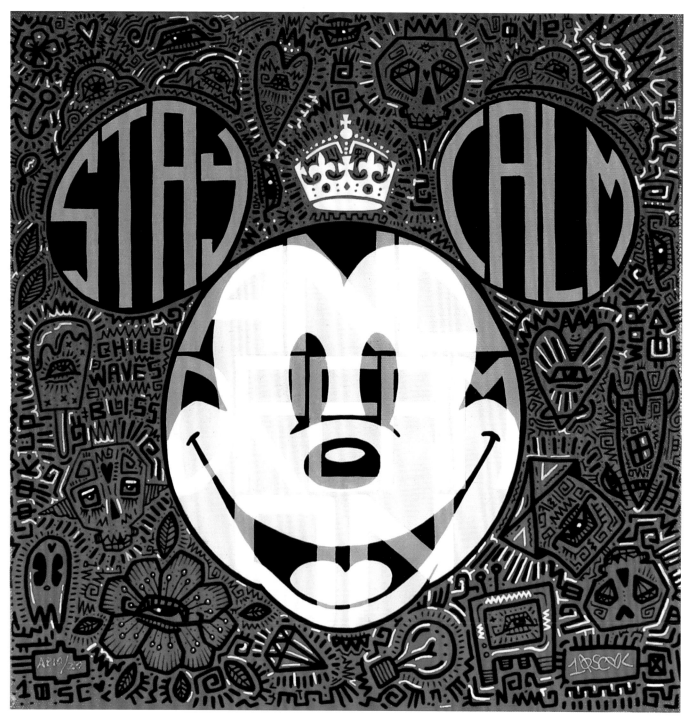

Tennessee Loveless. *Stay Calm and Scribble On* (2018)
Ink overlay on giclée | 14⅛ x 14⅛ inches

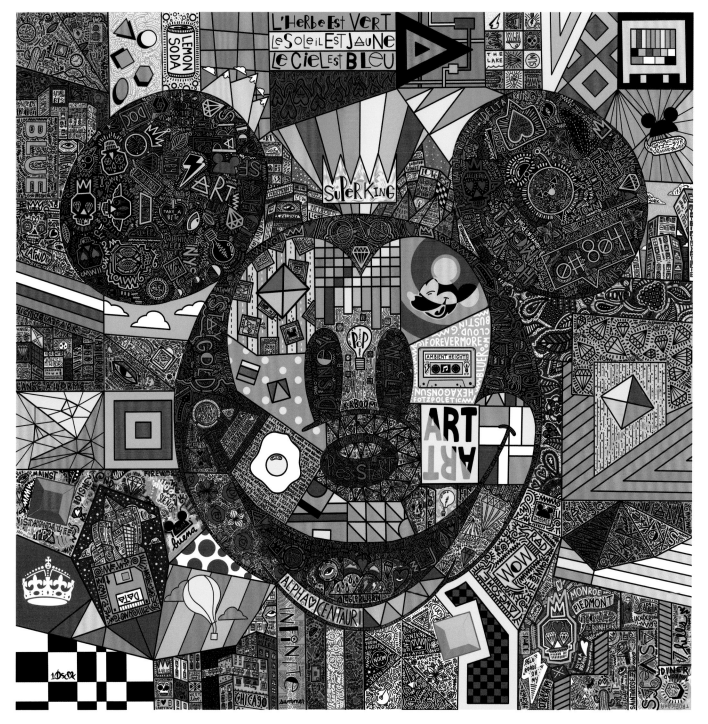

Tennessee Loveless. *Everything Bagel with Digital Schmear* (2019)
Digital illustration on canvas | 36 x 36 inches

Sirron Norris. *Generations* (2018)
Digital illustration on canvas　|　72 x 96 inches

Sirron Norris graduated from the Art Institute of Pittsburgh and began his art career in San Francisco in 1997. He was the recipient of the Artist in Residence programs at the de Young/Fine Arts Museums of San Francisco and Yerba Buena Center for the Arts in 2000 and 2002 respectively. Norris is known for his extensive public art contributions, among them his notable mural *Victorion: El Defensor de la Mission*, which is located in San Francisco's historic Balmy Alley. The Calumet Mural, located at the corner of 18th and Bryant Streets, currently stands as Norris's largest work to date at 600 square feet. Norris is also an accomplished artist across several mediums, including multimedia, television, film, and illustration. He was the lead artist on Fox Network's animated show *Bob's Burgers* (2001–), and his art career has been featured on the *PBS NewsHour* with Jim Lehrer as well as in several commercials and advertisements. Additionally, Norris has an ongoing political comic series entitled *City Fruit* for which he received the Greater Bay Area Journalism Award in 2017.

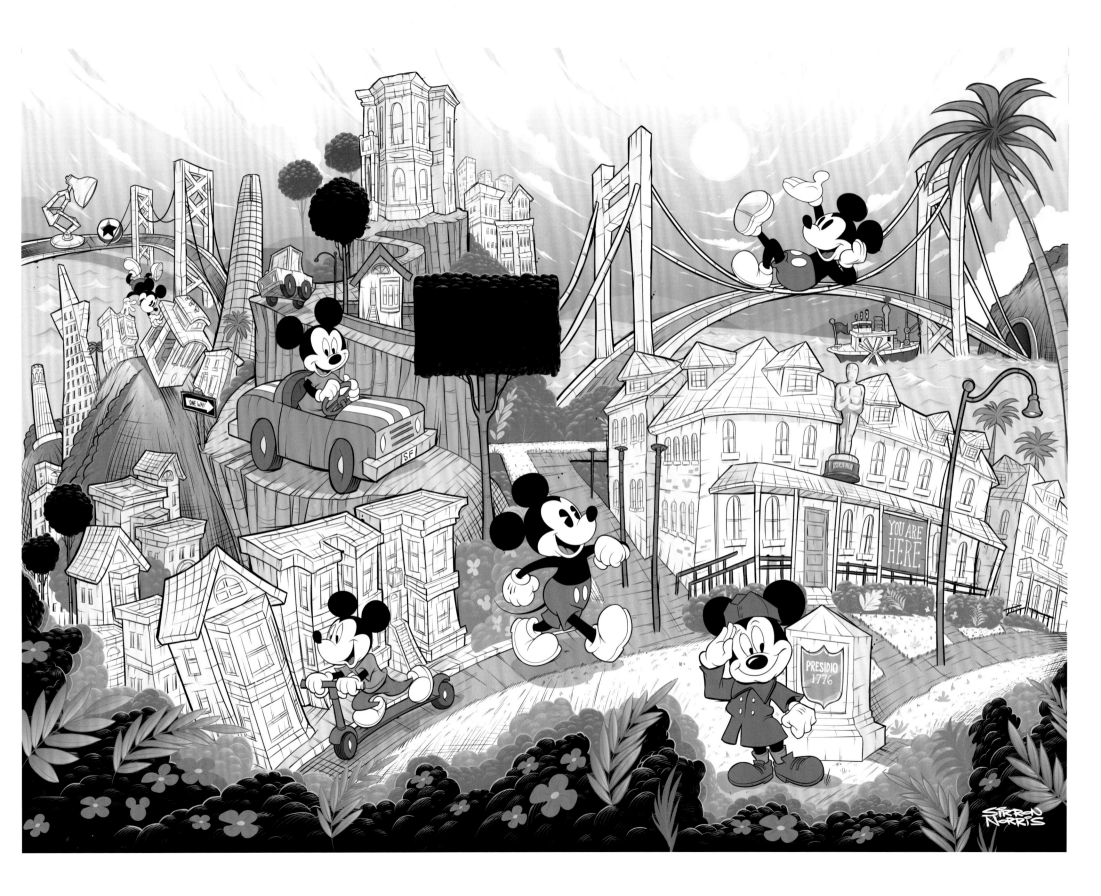

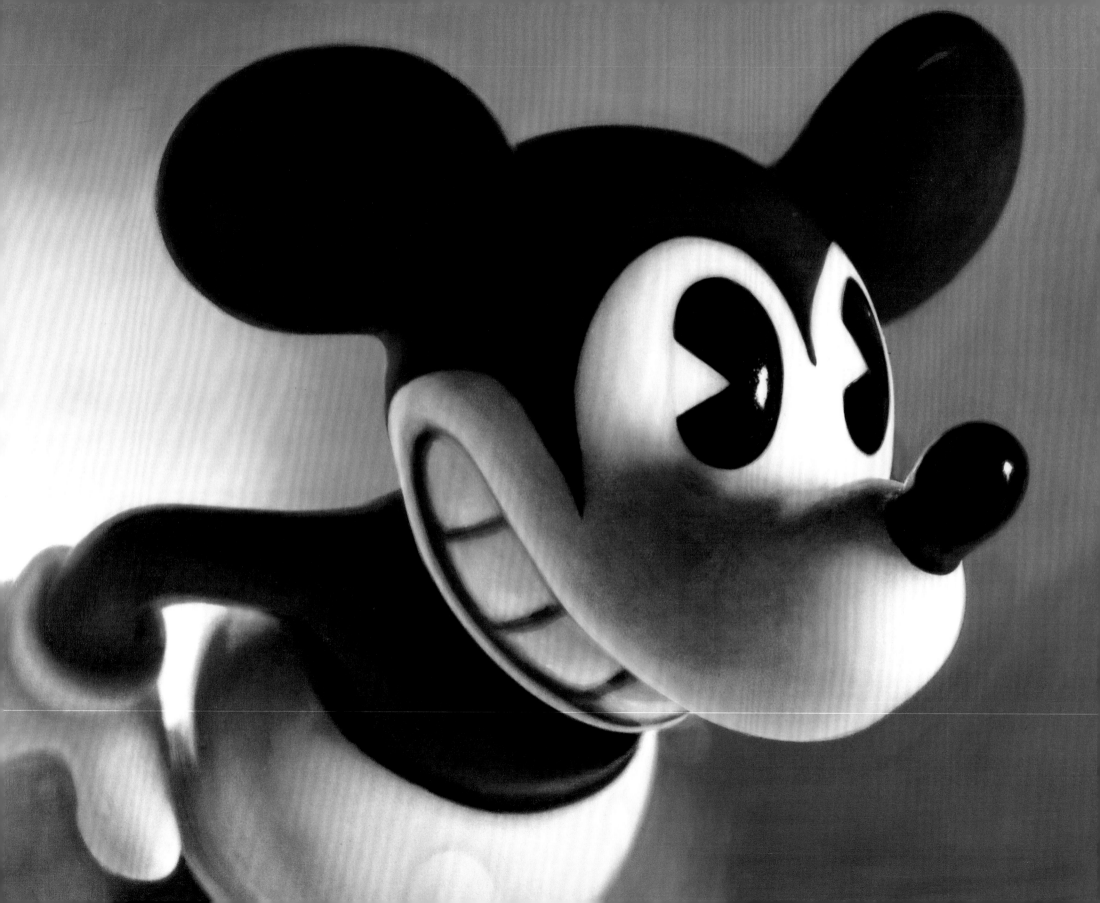

Gottfried Helnwein. *Mouse I* (1995)
Oil and acrylic on canvas | 83 x 123 inches

Gottfried Helnwein is an Austrian Irish painter, photographer, sculptor, and performance and installation artist perhaps best known for his photorealistic paintings of controversial, dark subject matter, including wounded children, as in his 1979 painting *Life Not Worth Living*, which led to his overnight fame and notoriety. His Mickey painting, done in shades of gray, also explores a seemingly innocent symbol and places in a darker, ominous context. His first solo show in the United States was held in 2004 at the Fine Arts Museums of San Francisco's Legion of Honor, and in 2009 Helnwein was awarded a Steiger Award for his contribution to visual arts.

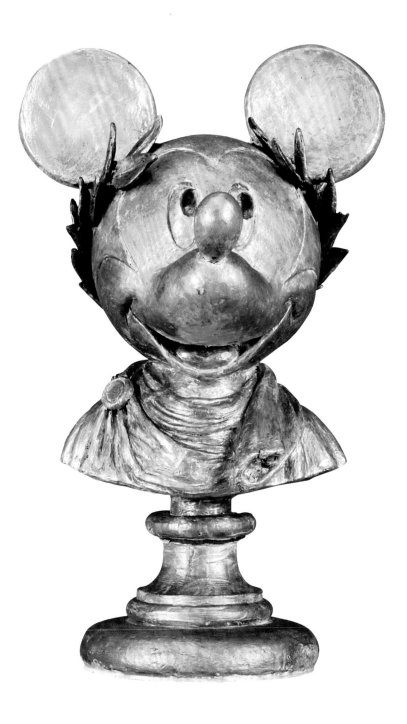

Robert Grossman is an award-winning artist with a career spanning more than 50 years. He grew up in Brooklyn, New York and later attended Yale University, before going on to illustrate more than 500 magazine covers. His distinctive, whimsical, and often satirical caricatures, cartoons, illustrations, and sculptures have been featured in various publications such as *The New York Times, The New Yorker, Rolling Stone, Sports Illustrated, The Nation, TIME, Newsweek, Esquire, New York Magazine, The Atlantic, National Lampoon,* and *Forbes.*

As an illustrator, Grossman has contributed to numerous album covers, book jackets, and movie posters, including the iconic poster for the film *Airplane!* (1980). Additionally, he has experienced success as an animator, having produced several TV commercials in the 1980s and being nominated for an Academy Award® for his short film *Jimmy the C* (1977). Other projects include the children's book *What Can a Hippopotamus Be?* (text by Mike Thaler); a debut illustrated novel, *Life on the Moon,* which came out in April 2019; and a 2013 commission from Diane Disney Miller to create artwork for a Walt Disney Family Foundation Press publication titled *Mickey Mouse: Emblem of the American Spirit.*

Robert Grossman. Mickey sculpture, gifted to Walt 2003
Plasticine and paint on a wood base | 10¾ x 7 x 6 inches

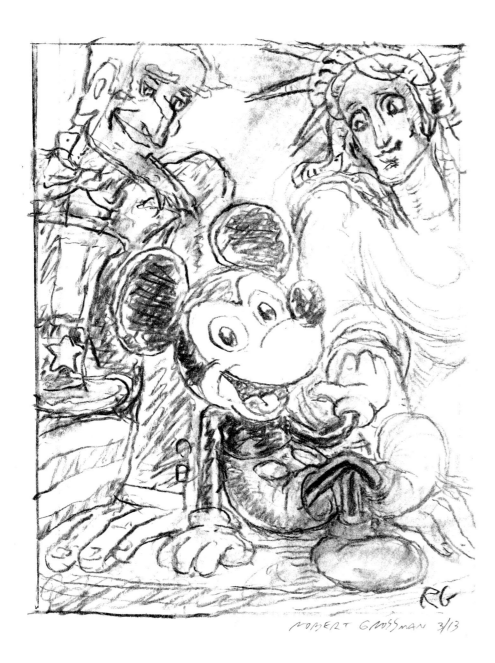

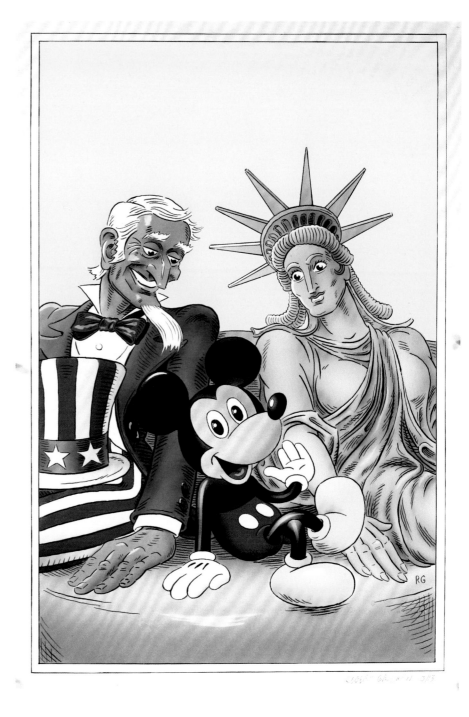

Robert Grossman. Concept art, 2013
Charcoal on paper | 11 x 8½ inches

Robert Grossman. Commemorative Mickey Mouse poster, final color artwork, 2013
Watercolor, ink, and graphite on paper | 23 x 16¼ inches

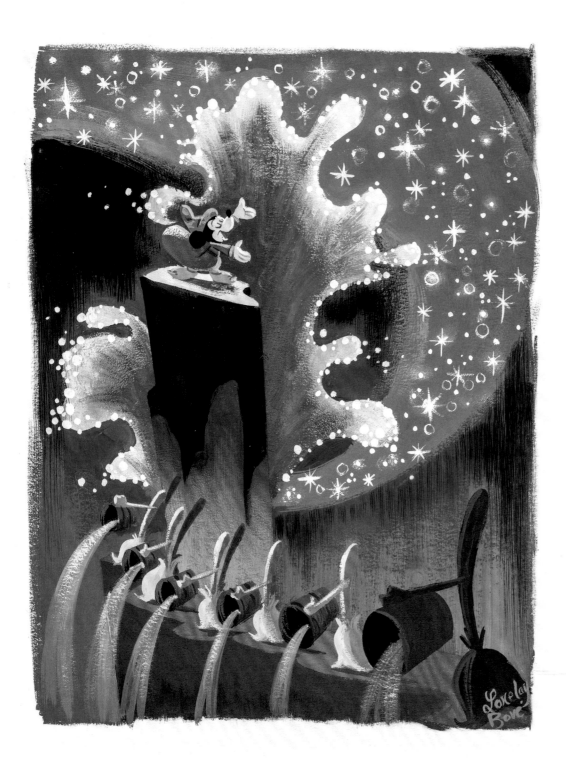

Lorelay Bové. Untitled.
Painting based on "The Sorcerer's Apprentice" segment
from *Fantasia* (1940)
Opaque watercolor on paperboard | 11½ x 9¾ inches

Lorelay Bové is a visual development artist from Spain who,
after graduating in 2007 from CalArts, made her entry
into animation as an art intern at Pixar Animation Studios.
Bové served as a visual development artist for Walt Disney
Animation Studios' Academy Award®–winning animated
feature *Big Hero 6* (2014). Prior to that, she contributed her
talents as lead designer of "Sugar Rush" for the big-screen
comedy *Wreck-It Ralph* (2012). She counts among her
Disney credits influential visual direction and development
roles on the animated features *The Princess and the Frog*
(2009), *Tangled* (2010), and *Winnie the Pooh* (2011), the
short film *Tangled Ever After* (2012), and on the multiple
Emmy® Award–winning TV special *Prep & Landing* (2009).

In addition to her visual development work for Disney's
animated films, Bové has also provided illustrations for
several Little Golden Books, including *The Princess and the
Frog, Toy Story: Ride 'em Cowboy!* and *Wreck-It Ralph*. Her
work was featured at the New Orleans Museum of Art's
exhibition *Dreams Come True: Art of the Classic Fairy Tales
from The Walt Disney Studios*, as well as other art exhibits
around the world. Bové is the illustrator of Walt Disney
Animation Studios Artist Showcase book, *No Slurping,
No Burping!: A Tale of Table Manners*. She has also created
new artwork for each of the 12 albums in *The Walt Disney
Records: The Legacy Collection* series.

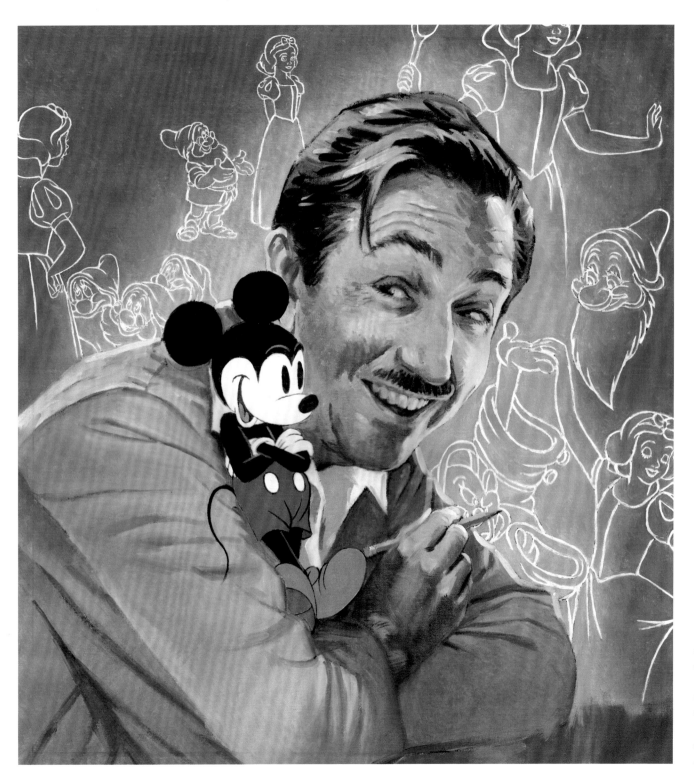

John Pomeroy. Original book cover artwork.
Walt's Imagination: The Life of Walt Disney (2018)
Oil on canvas | 34½ x 32½ inches

John Pomeroy is an American animator, producer, writer, and painter who majored in illustration at Art Center College of Design. Pomeroy was hired by The Walt Disney Company in 1973 as an animation trainee. After six months in the training program, he was assigned to animate on *Winnie the Pooh and Tigger Too* (1974) under the supervision of veteran animator Frank Thomas. Pomeroy also worked on *The Rescuers* (1977), *Pete's Dragon* (1977), *The Small One* (1978), and *The Fox and the Hound* (1981) before leaving Disney in 1979 with his partners Don Bluth and Gary Goldman in order to start Don Bluth Productions. There he animated and coproduced *The Secret of NIMH* (1982), *An American Tail* (1986), *The Land Before Time* (1988), *All Dogs Go to Heaven* (1989), and *Thumbelina* (1994). Pomeroy returned to Disney in 1992 to supervise animation of Captain John Smith in *Pocahontas* (1995), and he went on to supervise animation on *Atlantis: The Lost Empire* (2001) and *Treasure Planet* (2002). Pomeroy has been an active member of the Shorts and Animation branch of the Academy of Motion Picture Arts and Sciences since 1978.

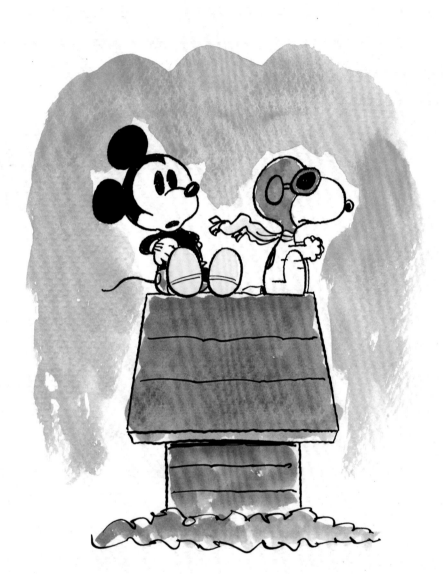

Charles M. Schulz. *Flying Ace Snoopy and Mickey Mouse*, 1980s
Watercolor on lithograph | 14⅛ x 11 inches

Charles M. Schulz was an American cartoonist known for the comic
strip *Peanuts*, which debuted on October 2, 1950, in seven newspapers
nationwide. Schulz, now credited as one of the most influential cartoonists
of all time, grew up reading the Sunday morning comics and became
fascinated with the likes of Skippy, Mickey Mouse, and Popeye. At the time
he announced his retirement in December 1999, the *Peanuts* comic strip
was syndicated in more than 2,600 newspapers worldwide. Schulz has been
awarded with the highest honors from fellow cartoonists, received Emmy®
Awards for his animated specials, and has had his work brought to life at
Knott's Berry Farm's Camp Snoopy in Buena Park, California, and at the
Charles M. Schulz Museum in Santa Rosa, California.

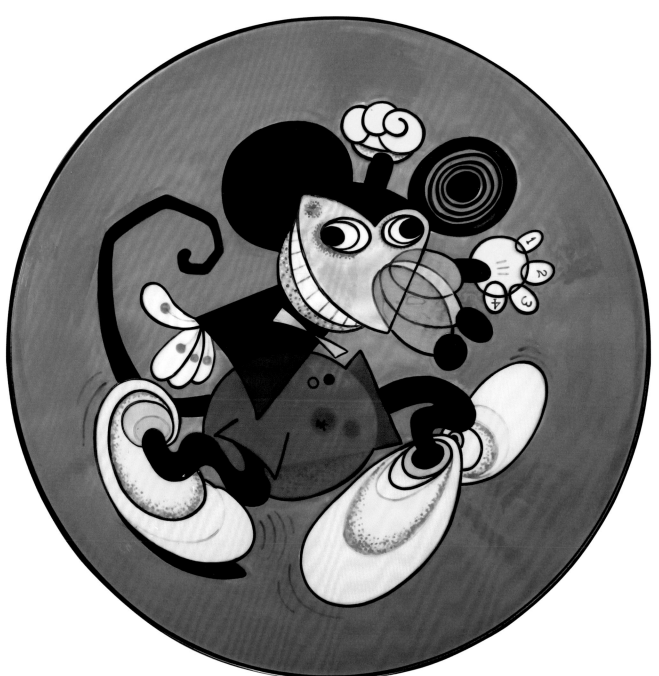

Ward Kimball. Abstract Mickey Mouse charger plate
c. 1990
Glazed ceramic | 17⅜ x 17⅜ x 3⅛ inches

Ward Kimball was a master animator, starting at The
Walt Disney Studios in 1934 and contributing to almost
all Disney animated features until his retirement in 1972.
One of the earliest projects Kimball worked on as an
inbetweener was the Mickey Mouse short film *Orphans'
Benefit* (1934). Kimball gradually worked his way up at
the Studios, even animating the iconic mouse in "Mickey
and the Beanstalk," which would later be released as a
segment of the package feature *Fun and Fancy Free* (1947).
Other notable Kimball characters include Jiminy Cricket in
Pinocchio (1940) and Lucifer the cat in *Cinderella* (1950).

Creative Growth Art Center is a nonprofit organization that serves artists with developmental, mental, and physical disabilities by providing a professional studio environment for artistic development, gallery exhibition, and representation. In 2012, Mickey Mouse was chosen as an inspirational theme by an artist at the studio. Diane Disney Miller later admired these works and purchased several of them, some of which were put on display at The Walt Disney Family Museum for the first time in the museum's small, temporary exhibition *Now Showing: Walt Disney's Mickey Mouse* (January 23–September 9, 2019).

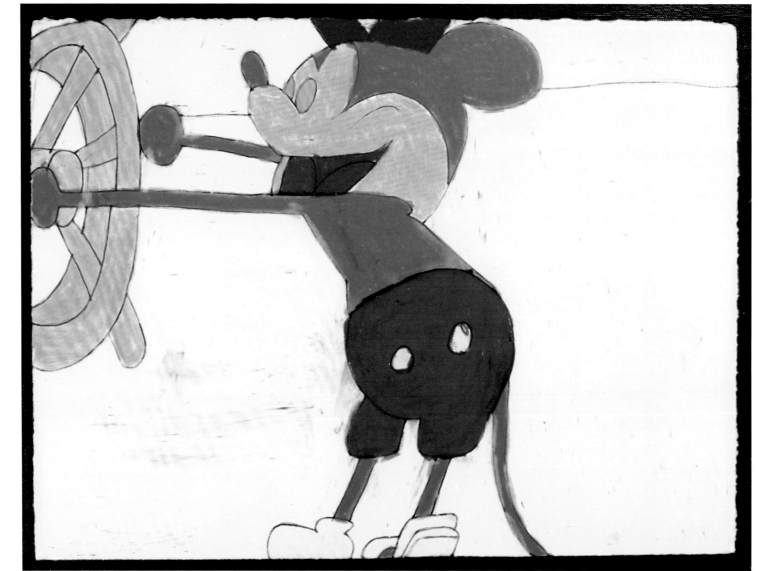

Ron Veasey, Creative Growth Art Center.
Steam Boat Mickey (2012)
Prismacolor stick on paper
mounted on canvas | 12 x 16 inches

Ron Veasey is a quiet, thorough artist who enjoys working methodically and independently. His paintings and drawings all possess a careful precision that is evident through his use of line and composition, which he delineates with flat, vivid colors. The sharp contrast in hues carry as much compositional weight as the few key details he chooses to include. Sourcing his images primarily from fashion magazines, photography books, or *National Geographic* catalogs, Veasey's work consists primarily of people with the occasional wildlife study. Veasey has been making art at Creative Growth since 1981.

John Martin, Creative Growth Art Center. *Mickey* (2012)
Marker on paper mounted on canvas | 16 x 12 inches

John Martin creates drawings from his memories of time
spent with his family on their Arkansas farm. Each drawing
is instantly recognizable through the use of John's signature
imagery: trucks, snakes, pocket knives, and cell phones as well
as the occasional found object he discovered on the streets
of Oakland, CA. Most recently, Martin has been using found
paper in his work, taking text from news stories and weaving
them together with his unique imagery, often by drawing
directly on newsprint and pages from phone books. In 2014,
he was invited by Facebook to create a site-specific artwork as
part of the inaugural Artist-In-Residence (AIR) program at the
new Frank Gehry–designed Facebook campus. Martin has been
an artist at Creative Growth since 1987.

"Mickey Mouse is my favorite actor! Minnie Mouse is my favorite actress! My very own favorite personal hero is Walt Disney."

—Andy Warhol

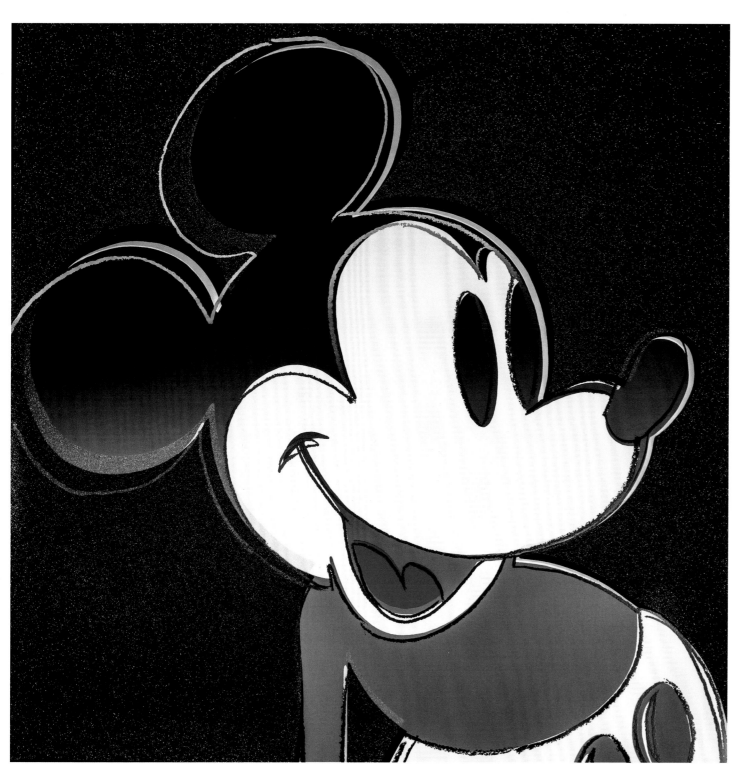

Andy Warhol. *Mickey Mouse* (1981)
Screen print and diamond dust on paper
42½ x 42½ inches

Andy Warhol was an American artist, director, producer, and a leading figure in the pop art movement. Warhol aimed to challenge the very definition of art by leaving behind the notion of originality—traditionally a tenant of esteemed artworks—in the pursuit of accessible, mass-produced works, most notably silk screens, that featured elements of commercialism and popular and celebrity culture. Warhol's Mickey Mouse screen print is one in a 10-part series known as his *Myths* series, which spotlights other iconic characters such as Superman, Howdy Doody, and Santa Claus.

Eric Robison. *Hit the Big Time* (2018)
Acrylic on board | 48 x 36 inches

Eric Robison began his career as an artist in 1987 when he
was hired by Walt Disney Imagineering as a show concept
designer. While there, he worked at Disneyland Paris Resort,
Tokyo Disneyland Resort, Walt Disney World Resort, and
Disneyland Resort. Imagineering President Marty Sklar
discovered Robison's work in 1989 and Robison became a
best-selling artist in Disney theme parks, galleries, and stores.
In addition to his 19-year stay with Disney, he has been a
consultant for MCA/Universal Studios, Warner Bros., and the
Olympics, among others. In 2006 he joined Crazy Shirts in
Hawaii as the creative director.

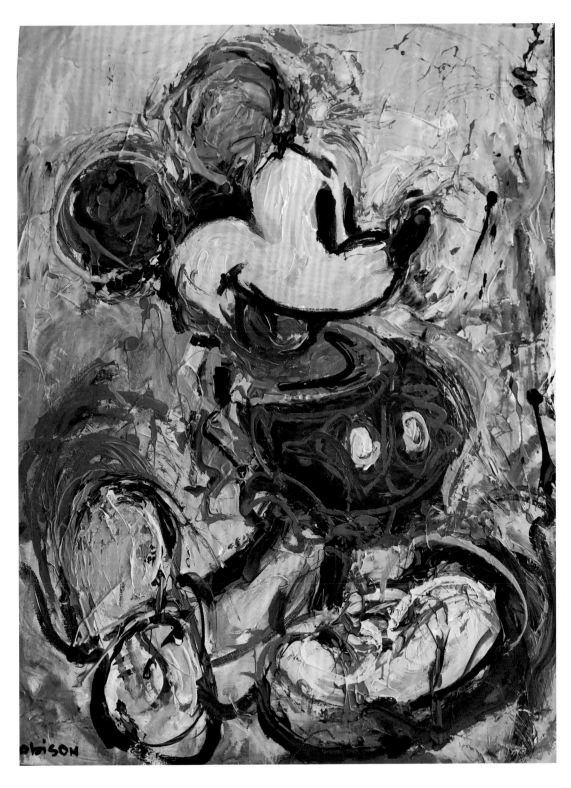

Eric Robison. *Effervescent Mouse* (2018)
Acrylic on board | 48 x 36 inches

THE RETURN OF MICKEY

MICKEY MOUSE MADE HIS COMEBACK in movie theaters with the animated featurette *Mickey's Christmas Carol* (1983), thirty years after his last big screen performance in *The Simple Things* (1953). The critically acclaimed film received an Academy Award® nomination and quickly became a holiday tradition. Mickey was later featured in *Who Framed Roger Rabbit* (1988), which helped launch a cartoon renaissance. He then starred in *The Prince and the Pauper* (1990) and stepped out in an untraditional role in *Runaway Brain* (1995).

Mickey appeared in a freshly animated television series, *Mickey Mouse Works*, which debuted in 1999. Steadfast in growth and public demand, Mickey's television career continued to expand with *Disney's House of Mouse* in 2001, establishing him as a contemporary television presence. Mickey is currently seen on the airwaves in the stylish series *Mickey Mouse*, a program that began in 2013 and was inspired by a synthesis of early Mickey Mouse designs and his more modern iterations from the 1950s.

An earlier syndicated television series, *The Mouse Factory*, produced by Walt Disney Productions and created by animator Ward Kimball, ran from 1972 to 1973. Celebrity guests, including Annette Funicello, Phyllis Diller, Jo Anne Worley, and others—credited as "Mickey's Friends"—hosted the program, showing clips from Disney cartoons and movies. The theme that played over the previews of each episode was a fast instrumental version of "Whistle While You Work" from *Snow White and the Seven Dwarfs* (1937). "Minnie's Yoo Hoo," first performed in *Mickey's Follies* (1929) and the theme song from the original theater-based Mickey Mouse Club program that began in 1930, played over the end credits.

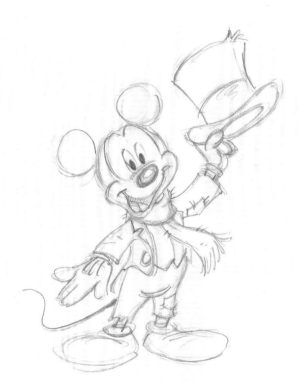

Mark Henn. Drawing inspired by *Mickey's Christmas Carol* (1983), 2018
Graphite and colored pencil on paper | 17 x 12 inches

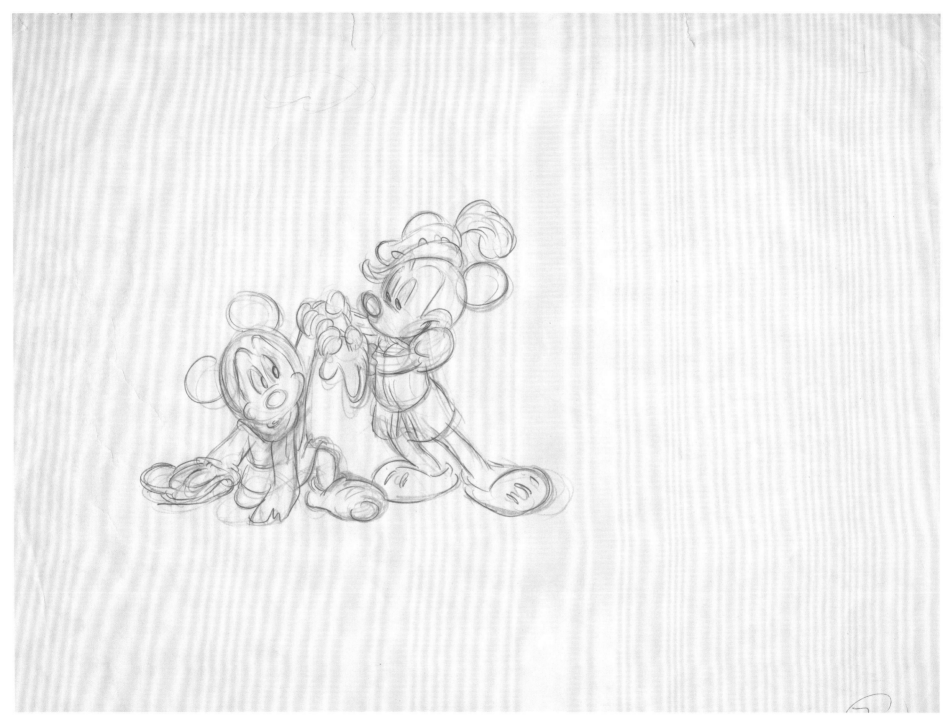

Andreas Deja. Rough animation drawing. *The Prince and the Pauper* (1990)
Graphite and colored pencil on paper | 12½ x 17 inches

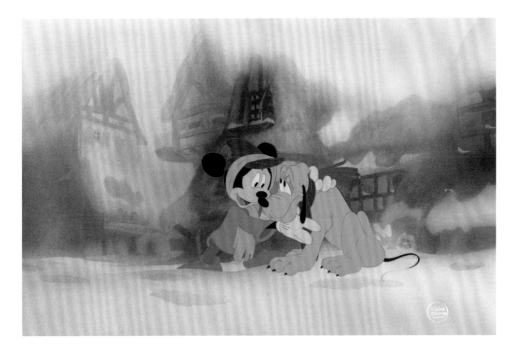

Disney Studio Artists. Production cel on printed background.
The Prince and the Pauper (1990)
Paint on cel, printed background | 11 x 16 inches

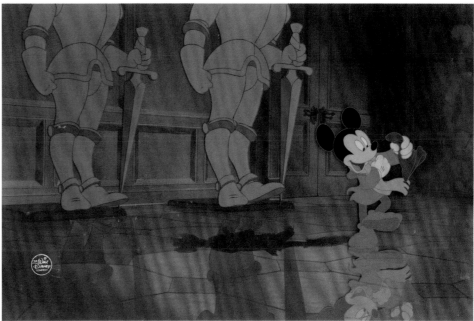

Disney Studio Artists. Production cel on printed background.
The Prince and the Pauper (1990)
Paint on cel, printed background 11 x 16 inches

MICKEY NOW

WITH DEVELOPMENTS IN ANIMATION TECHNOLOGY, Mickey Mouse has also evolved. Maintaining the same adventurous spirit and humor as before, the new Mickey shorts largely evoke the character designs of the 1930s. The shorts of the past relied on visual humor and slapstick comedy, and thus required little dialogue; the new shorts do the same. This reinvigoration of Mickey for new audiences recalls the past by featuring characters with "pie eyes," and through its use of "rubber hose" animation—a distinctive and flexible animation style that allows characters to move as if they have no bones. Using this same technique with 3-D animation brings the nostalgia of the past into the present, offering young and old alike something to identify with.

The short *Get A Horse!* debuted on the big screen in 2013, showcasing a seamless combination of 2-D and 3-D animation. With initial screenings at the Annecy International Film Festival and at Disney's D23 Expo during the summer, this short holds the distinction of being the first Disney animated film to be directed by a woman, Lauren MacMullan—though its theatrical release in November 2013 was with Disney's animated feature *Frozen*, for which Jennifer Lee shares directorial credit. *Get A Horse!* utilizes the techniques and style of the shorts from Mickey's early career, and archival recordings have allowed Walt to voice Mickey once again.

▸ Eric Goldberg. Drawing inspired by *Get A Horse!* (2013), 2018
Graphite and colored pencil on paper | 12 x 17 inches

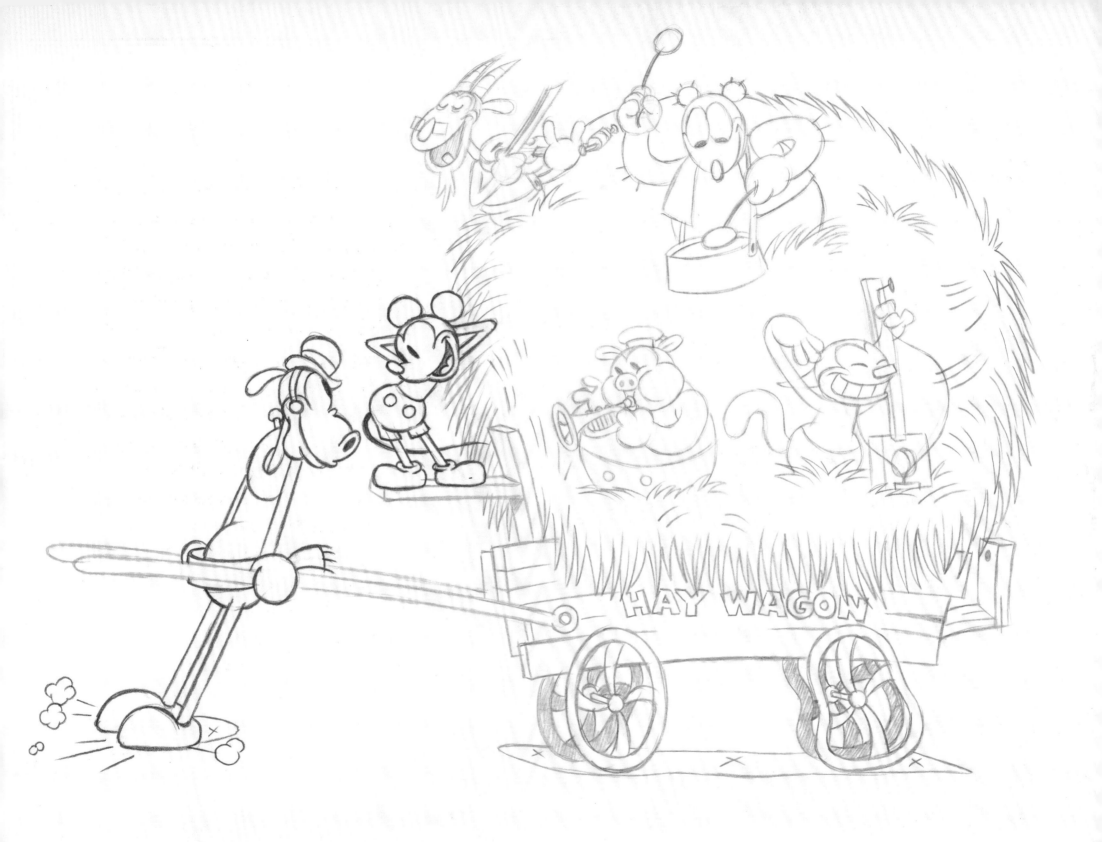

Published by The Walt Disney Family
Foundation Press®, LLC.
104 Montgomery Street in the Presidio
San Francisco, CA 94129

A weldon**owen** production
President & Publisher Roger Shaw
SVP, Sales & Marketing Amy Kaneko
Associate Publisher Mariah Bear
Editorial Assistant Madeleine Calvi
Creative Director Kelly Booth
Art Director Allister Fein
Designer Debbie Berne
Production Designer Lisa Berman
Production Director Tarji Rodriguez
Production Manager Binh Au
Imaging Manager Don Hill

www.weldonowen.com

Library of Congress Cataloging in Publication
data is available.

ISBN: 978-1-68188-468-4
10 9 8 7 6 5 4 3 2 1
2019 2020 2021 2022 2023
Printed in China

Artwork and Artifact Lenders
Tony Anselmo: 5, 16, 50, 52, 53, 54, 56, 57, 58, 63,
67, 72, 82, 97 Lorelay Bové: 152 Andreas Deja: 8,
48, 49, 61, 67, 69, 78, 79, 80, 81, 106, 108, 164, 165
Mike and Jeanne Glad: 16, 17, 18, 21, 34, 42, 44, 46,
51, 53, 55, 56, 58, 59, 60, 65, 69, 81, 83, 92, 93, 103,
104 Eric Goldberg: 167 Bonnie Grossman: 149
Mark Henn: 163 Damien Hirst: 141 Bob Iger and
Willow Bay: 141 Tennessee Loveless: 142, 143, 144,
145 Joanna Miller: 19, 35, 64, 140 Ron and Diane
Miller: 41, 135, 159 Ron Miller: 155 Tamara Miller:
28, 29 Pete Morolo: 98 Sirron Norris: 147 John
Pomeroy: 153 Eric Robison: 160, 161 San Francisco
Museum of Modern Art: 138, 139, 148 Charles M.
Schulz Museum and Research Center: 153 Smoke
Tree Ranch Disney Hall: 137 Miri Weible: 26, 37,
71 Walt Disney Family Foundation: 4, 10, 16, 17,
20, 22, 23, 24, 25, 27, 30, 31, 32-33, 36, 43, 45, 60,
73, 75, 76, 78, 83, 84, 85, 86, 87, 88, 89, 90, 91, 96,
110, 111, 113, 114, 116, 117, 118, 119, 120, 121, 122, 125,
127 Jeri Ward: 116

Artwork Donors
All gifts belong to the Walt Disney Family
Foundation.

Dean Barickman: 102, 105, 113, 122, 132 Kokonino
Collectibles: 71 Suzanne Hiller Herrick: 116 Peter
Merolo: 27, 47 Diane Disney Miller: 76, 77, 112,
131, 136 Ron and Diane Miller: 15, 39, 54, 96, 111,
123, 129, 130, 132, 133, 136, 151, 156, 157 Joanna
Miller: 98, 99, 100, 101 Walter E.D. Miller: 52,
62, 95, 96, 97, 109, 111, 112, 114, 115, 118, 119, 121,
131 Alexandra Hurrell Palazzola: 111 Family of
Geraldine A. Peters: 116 George Sells in honor of
Diane Disney Miller: 128, 131 Maureen Shields: 117
Jeri Ward: 122

Artwork Copyright
All images are © Disney except where noted below.

Lorelay Bové: 152 Charles Boyer: 137 Robert
Grossman: 151 Gottfried Helnwein: 148 Damien
Hirst/Science Ltd. All rights reserved, DACS 2019:
141 Matsumi Kanemitsu: 138, 139 Tennessee
Loveless: 142, 143, 144, 145 John Martin, Creative
Growth Art Center: 157 Sirron Norris; 147 John
Pomeroy: 153 Eric Robison: 160, 161 Charles M.
Schulz, 2019 Peanuts Worldwide LLC: 154 Wayne
Thiebaud: 137 Ron Veasey, Creative Growth Art
Center: 156 The Andy Warhol Foundation for the
Visual Arts / Artists Rights Society (ARS) New
York: 159

Acknowledgments
The Walt Disney Family Foundation Press would
like to acknowledge the following individuals
for their contributions to this book: Kate Bove
and Kaitlin Buickel—content development
and copywriting; Bri Bertolaccini, Paula Sigman
Lowery, and Caroline Quinn—copyediting and
fact-checking; Marina Villar Delgado, Caitlin
Moneypenny-Johnston, Jamie O'Keefe, and
Tara Peterson—production assistance and asset
management; and Mark Gibson—photography
and digital asset management.

A Walt Disney Company

Walt Disney Archives
Rebecca Cline, Justin Arthur, Holly Brobst,
Michael Buckhoff, Maggie Evenson, Kevin Kern,
Ed Ovalle, Joanna Pratt

Walt Disney Animation Research Library
Fox Carney, Kristen McCormick, Mary Walsh

Corporate Legal
Margaret Adamic

Corporate Communications
Zenia Mucha, Jeffrey Epstein

Franchise Management
Alyssa Tryon

Brand Management
Charlie Cain

Weldon Owen would like to thank Marisa Solís
for her editorial expertise.

**The Walt Disney Family Museum and
Walt Disney Family Foundation Staff**

Jan Abueg
Liz Anderson
Larry Arndt
Mel Asher
Marlon Baez
Cara Bardine
Rachel Barletta
Maryellen Beauperthuy
Bri Bertolaccini
Kate Bove
Sheena Boyd
Emilee Bozzard
Kaitlin Buickel
Shawn Carrera
Natalie Chan
Tiffany Ting-Ting Chen
Alison Chenoweth Revel
Paige Collins
Katherine Coogan
Katlin Cunningham
Antonia Dapena-Tretter
Aaron Devera
John Ferris
Alyson Fried
Hayley Gardner
Mark Gayapa
Emmeline Geyer
Mark Gibson
Carla Gonzalez
Lara Hayner
Nicole Hellmann
William Hoffmann
Joey Ingrum
Kirsten Komoroske
Nell Krahnke
Jenna L'Italien-Uppal
Travis Lacina
Julian Lacombe
Grace Lacuesta
Julie Long Gallegos
Caitlin Manocchio
Summer McCormick
Courtney McNellis
Anita Meza
Caitlin Moneypenny-Johnston

Tonja Morris
Ryan Mortensen
Christopher Mullen
David Nadolski
Mayumi Nguyen
Andrew Nilsen
Jamie O'Keefe
Joshua Lee Pearl
Darcy Pease
Tara Peterson
Marina Place
Caroline J. Quinn
Matt Ramos
Sarah Rothstein
Martin Salazar
Christine Shedore
Maureen Shields
Tabitha Smith
Rick Stone
John Stroh
Peter Susoev
Channing Tackaberry
Elizabeth Tanner
Danielle Thibodeau
Tracie Timmer
Emily Vann
Marina Villar Delgado
Deb Waltimire
Thomas Wan
Nancy Wolf